charles h. gibbs-smith

Keeper Emeritus, Victoria and Albert Museum

the Bayeux tapestry

phaidon

Photographs by Percy Hennell

Phaidon Press Limited, 5 Cromwell Place, London sw7

Published in the United States of America by Phaidon Publishers, Inc.
and distributed by Praeger Publishers Inc.
111 Fourth Avenue, New York, N.Y. 10003

First published 1973
©1973 by Phaidon Press Limited
All rights reserved

ISBN 0 7148 1593 4
Library of Congress Catalog Card Number: 72-93431

Text printed in Great Britain by R. & R. Clark Ltd., Edinburgh
Illustrations printed by Cavendish Press Ltd., Leicester

FOREWORD

I am happy to be the means of bringing back to schools, colleges and the general public a Phaidon Press production of the Bayeux Tapestry, as the great comprehensive survey issued in two editions by the Press (see Bibliography) has long been out of print. My function in that work was in compiling extensive notes to the plates, based on the scholarship of my colleagues; and my dependence on those colleagues – three of whom are now dead – still permeates the present work. My own contributions are comparatively small, being focused on the final proof that Harold was not hit in the eye by an arrow at the Battle of Hastings, and to the deployment of arguments which, in my opinion at least, make it certain that Harold did not travel to Normandy intentionally in order to offer the Throne to William on the death of Edward the Confessor, as the Tapestry – with its purely Norman briefing – would have us believe. In the original book, I felt obliged to modify my remarks out of respect for the views held by our Editor, the late Sir Frank Stenton. My opinions today are even stronger than they were then, and I have now set them down accordingly, and free of restraint.

Another important difference in my treatment of the Tapestry is seen in my complete conversion to the views expressed subsequently by C. R. Dodwell in the *Burlington Magazine* (see Bibliography) regarding the secular nature of the Tapestry. I am glad to record here that a number of my most distinguished former colleagues have also been convinced that C. R. Dodwell is correct.

I should like to express particular gratitude for their present help to John L. Nevinson, formerly in the Dept. of Textiles, Claude Blair, Keeper of the Dept. of Metalwork, and George Wingfield Digby, Keeper Emeritus of Textiles, Victoria and Albert Museum.

C. H. G.-S.

INTRODUCTION

The Bayeux Tapestry is not really a tapestry but a long stretch of embroidery in wool on linen, which is owned and exhibited by the little city of Bayeux, in the Department of Calvados, five miles inland and seventeen miles west-north-west of Caen. The Tapestry was almost certainly commissioned by Bishop Odo of Bayeux, who in 1067 was made Earl of Kent by his half-brother William the Conqueror. Tradition holds that it was commissioned for Odo's new Cathedral at Bayeux, which was consecrated in 1077, but this view is becoming discredited by a closer study of the Tapestry and its contemporary parallels. It is a secular record, clearly carried out with secular intentions, and not an ecclesiastical work made for display in a cathedral (see The Nature and Destination of the Tapestry). It was, we now believe, destined for a castle.

The Tapestry was probably commissioned soon after 1066, and would not have taken more than two years to complete. It was, of course, made to a Norman brief, but was designed in England and embroidered in England by English craftswomen. The conclusion that it has such an English provenance is based on comparisons with contemporary illuminated manuscripts and other pictorial sources, and on the English spelling of names in the Latin inscriptions. It would, after all, be natural for the new foreign lord of an English province to have the work carried out by the conquered. Apart from the dates connected with Bishop Odo and his Cathedral, the number of local and topical allusions in the Tapestry – which would have been meaningless at a later date and are still meaningless today – also confirms a near-contemporary dating for the work.

The Tapestry presents the pictorial story of the events that led up to the invasion of England by Duke William of Normandy; of the invasion itself; and of King Harold's defeat and death by William's army at the Battle of Hastings on 14 October 1066. The story is presented as a factual narrative of events; but it is in fact little more than a mendacious propaganda 'strip-cartoon' designed to justify William's unjustifiable invasion of England in what an earlier historian has described as a 'piratical venture'.

However deplorable as an historical record, it is a superb work of art, and we are indeed fortunate that it has survived in such good condition after the wear and tear – to say nothing of the wars and strife – of nine centuries.

THE NATURE AND DESTINATION OF THE TAPESTRY

It seems always to have been taken for granted in the past that the Tapestry was commissioned by Bishop Odo (c. 1036–97) for his new Cathedral at Bayeux, which was dedicated in 1077. Odo almost certainly did commission the work, but purely as a secular entertainment, not as a religious decoration. In 1966 C. R. Dodwell (see Bibliography) made out an overwhelming case for rejecting the ecclesiastical tradition, and this is now gaining wide acceptance.

Odo himself was first and foremost a tough feudal lord, a warrior and statesman, who acted as viceroy for his half-brother, William the Conqueror, when the latter was away, and also led punitive military expeditions against any rebellious factions which arose. He had accumulated vast wealth by extortion and robbery. Second, by a very long way, he happened to be a bishop, but it was in name rather than in spirit, although he is said to have had some saving qualities.

The Tapestry has nothing whatever to qualify it as a religious decoration, let alone as a

decoration for a cathedral. It is a purely secular document throughout, and even William – whose religious piety was sung by his admirers – is not shown in any religious activity in the Tapestry. And as for Bishop Odo himself, the only religious part he plays in the whole Tapestry is saying grace before a banquet! But he is shown to great effect taking his place in a military conference, and then riding into battle wielding a giant war-club. Even Harold's oath-taking scene (Fig. 24) takes place in the open air, not in the Cathedral; and William looks on, holding a great sword of state.

The whole story as told by the Tapestry is a feudal drama; a drama of promises made and oaths taken, of perjury, of retribution, of battle, and violent death. There are also two blatant scenes of nudity and lewdness in the border which would scarcely have been suitable in a work made for display in a cathedral. In addition, the size of the Tapestry (over 230 ft long) makes it highly unsuitable for hanging in the Cathedral; and when it finally came to decorate that building, it had to be hung high up from the columns of the nave, and either to pass above the west door, or go right across the aisle, for its return run; whereas the Tapestry would have been of an ideal size and length to be hung low down round the great hall of a castle. What is more, there is no evidence of any early connection between the Tapestry and Bayeux Cathedral, the first mention of its presence there being in 1476 (see History of the Tapestry).

Apart from these considerations, C. R. Dodwell has shown the Tapestry to bear the closest parallels with the nature and structure of the *chansons de geste*, those great medieval epics of adventure, battle and heroism which were recited before the lord and his guests after their evening feasting. There were two basic forms of *chanson*, the feudal story and that featuring the crusades. There was something of a set formula for many *chansons* of the first type; they dealt with feudal loyalty and disloyalty, and involved primarily, as Dodwell says, 'the treachery . . . of a vassal to his legitimate feudal seigneur, a treachery made all the more infamous – as in some of the *chansons* themselves – by the fact that, on a personal level, the seigneur has already shown himself to be the vassal's saviour and friend'.

The Bayeux Tapestry closely follows this formula, and we see – angled to tell the story as if Harold went intentionally to France – the rescue of Harold from the clutches of Guy of Ponthieu by William; the friendship shown to Harold by William; the ceremony of 'giving of arms' to Harold, thus making him William's man; Harold taking oaths of allegiance to William; then Harold committing perjury, and treacherously – from the Norman standpoint – accepting the Crown of England instead of sending for William; followed by the inevitable retribution inflicted by William in battle, and the justly deserved death of Harold in action. Such a plot was 'custom-made' for a *chanson*-type narration, and it fitted perfectly into the feudal pattern of such an epic.

Dodwell also shows that even the border is enlisted in the overall structure of this secular epic, and is meant to be seen in conjunction with it. 'But what is particularly significant about them', he writes, 'when we read the collection [of scenes] as a whole is that they have all been selected to point the same kind of moral. It is, indeed, the very moral of the main narrative – the moral of treachery and betrayal.' Wherever there is an animal fable, it is the story of an animal 'betrayer'.

Dodwell sums up his conclusions by saying that the Tapestry 'is, in fact, the only important monument of secular narrative art that has come down to us from the eleventh century'.

The fact that it was later hung in Bayeux Cathedral on certain annual occasions has no significance. By the time we first hear of it in the Cathedral's possession, it has become part of the historic treasure of the ecclesiastical authorities, like many other priceless objects of secular art.

The Attribution of the Tapestry to Queen Matilda

It is not known how far back in history there started the French tradition that the Tapestry was embroidered by William's wife Matilda; and presumably no French historian of modern times takes such attribution at all seriously. But the visitor to Bayeux must get used to seeing numerous street notices about the town directing him to 'La tapisserie de la Reine Mathilde'. I have sometimes wondered whether – in this wayward attribution – there might not have been just a grain of truth. I wonder, for example, whether it might have been possible that Odo commissioned the Tapestry as a *gift* to Queen Matilda, and that it found its way back to Rouen, and thence to Bayeux. It is reported by Wace and Odericus Vitalis that, after William's death, dishonest servants looted hangings from his palace at Rouen; and it is interesting to note that at the time of William's death, Bishop Odo was actually

imprisoned at Rouen. As he was immediately released, and even attended William's funeral, might he not – in the general confusion – have connived at the Tapestry being stolen from the castle at Rouen so that he could have it in Bayeux?

HISTORY OF THE TAPESTRY

The earliest mention of the Tapestry was in 1476, in an inventory of Bayeux Cathedral. Two and a half centuries were to pass before the next mention, when in 1724 a sketch appeared of part of it without its origin being known. In 1728–29 the Tapestry was engraved in full, and appeared in Montfaucon's *Monuments de la Monarchie Française*. In 1792, during the French Revolution, it came near to destruction when it was found that there was insufficient covering for the wagons of the Bayeux military volunteers, and the Tapestry was brought out for this use: however, it was rescued by M. Lambert Léonard-Leforestier, a local lawyer and administrator: after haranguing the mob, he took the Tapestry away to his office, where he kept it during the troubles. In 1794 it again came near to destruction, when there was a proposal to cut it up and decorate a float with it for a public holiday procession; but it was again rescued. In the same year, the Tapestry was marked down as a national treasure; was carefully examined; and then placed safely in store. In 1803, by command of Napoleon, it was sent to Paris and placed on exhibition. Napoleon then ordered it to be returned to Bayeux and made the property of the Municipality. In 1816 the Cathedral authorities petitioned for its return to them, but this was refused, as the Municipality said it had no power to part with it. In 1818–19 the English antiquarian Charles Stothard, at the expense of the Society of Antiquaries, copied the Tapestry and had it engraved, coloured and published in London in 1819. In 1842, after protests at the danger of allowing tourists to handle it, the Tapestry was placed on view under glass in the Public Library. In 1870, under threat of invasion by the Prussians, it was packed into a zinc container and hidden, but was soon after returned to the Library. In 1871 a full-size photographic copy of the Tapestry was made by E. Dossetter, and hand-coloured by Walter Wilson; it was commissioned by the British Government and placed in the South Kensington (later Victoria and Albert) Museum. In 1913 the Tapestry was transferred to the Old Episcopal Palace after it was secularized, and remained on exhibition there until 1939. In 1939 it was stored in the basement of that building, but was sometimes shown to the German troops by winding it from one spool to another. In 1941 the German authorities had it removed for study and photography to the Abbey at Juaye-Mondaye. After this, still in 1941, it was sent for safety to the Château de Sourches, near Le Mans. After the Allied landings in Normandy in 1944, it was taken to Paris and stored safely in a cellar of the Louvre, where – following the liberation of Paris – it was exhibited in the galleries. In 1945 the Tapestry was returned to Bayeux, where, after temporary arrangements, it was at last fittingly housed on the first floor of the former Bishop's Palace. In 1966 an abortive effort was made to borrow the Tapestry for exhibition in the Victoria and Albert Museum.

TECHNICAL DETAILS

The Bayeux Tapestry is technically an embroidered hanging, which was displayed annually – on the Feast of Relics and during the Octave of St. John – in Bayeux Cathedral, being hung presumably fairly high on the columns of the nave, running down one side; then across; then up the other side. It is 230 feet $10\frac{1}{4}$ inches (70.34 metres) in length, and about $19\frac{3}{4}$ inches (50 cm.) deep. It is worked in coloured wools against the plain background of the bleached linen, with eight colours being used, *i.e.* terracotta red, blue-green, sage-green, buff, full blue, a darker green, yellow, and a very dark blue. The method of embroidery is laid and couched work, with the additional use of stem and outline stitch. The Tapestry is made up of eight strips of varying lengths, but it should be remembered that a foot or two is missing from the end. The use of the colours is very imaginative, and greatly contributes to the vitality of the design; the legs on either side of a horse or dog are, for example, worked in different colours. The design would probably first be drawn on the linen, after a detailed brief had been given to the designer, and approved by the patron. The linen strips would then have been mounted on frames – to allow both hands free for the embroideresses – and one or more teams would be set to work simultaneously. The work to be done seems formidable indeed; there are 626 human figures, 190 horses, 35 dogs, 506 various other

animals, 37 ships, 33 buildings and 37 trees or groups of trees. However, it is estimated by my colleagues in the Textiles Dept. of the Victoria and Albert Museum that, with the team-work already noted, the Tapestry could have easily been completed within two years.

The Tapestry, as may well be imagined, has suffered considerably over the centuries, and parts of it were extensively restored in the nineteenth century. It is the only embroidered hanging of its kind to survive.

ICONOGRAPHY

The Architecture shown in the Tapestry

The reader is referred to the highly specialized contribution by R. Allen Brown to the original Phaidon edition of the Tapestry for a discussion of the architecture as shown in the Tapestry. Here it need only be said that, in general, the buildings shown are presented in purely formalized versions, meant only to symbolize the actual type of building, *i.e.* church, castle, mound-castle, tower, and so on. The possible exception is Westminster Abbey (Figs. 25, 26) which may resemble the new building consecrated at the end of 1065. R. Allen Brown also points out that the number of superbly executed arcadings – symbolizing the great halls of contemporary castles – supports other evidence as to the great importance of these large chambers in the everyday life of the time.

Arms and Armour

The weapons to be seen in the Tapestry include the lance and spear, the sword, the mace (or club), the axe, and the bow and arrow. The horseman's lance was a light, handy weapon; when carried by the leading horsemen, or other commanders, it had attached to the top (below the head) a small flag with a square body and three or more tails, or 'flies', called a gonfanon (or, later, gonfalon), which was derived from the Norse war-flag: it would probably display a symbol of rank or authority. On one occasion there occurs a semicircular gonfanon (Fig. 34), which was probably derived from the Norse raven-flag. The lance was often used, javelin-fashion, as a missile (Fig. 46). The infantry spear seems to have been a similar weapon.

Most of the horsemen, and some of the infantry, carried broad two-bladed swords, in leather-covered wooden scabbards. Sometimes the men wore them inside the hauberk, with the hilt projecting, ready to hand, through a slit in the mail (Fig. 9); otherwise they were worn outside (Fig. 42).

The mace was a formidable weapon with a spiked or knobbly head of iron fixed on the top of a wooden shaft; sometimes it appears in the form of a wooden club (Fig. 35). The mace was sometimes used as a missile (Fig. 46).

The war-axe was the so-called 'Danish' (or Viking) axe, a large two-handed weapon with strongly curved blade, particularly well-suited for defence and much favoured by the English (Fig. 15), which could easily cleave through a horse's head.

The bow then in use was the so-called Danish short bow, a comparatively ineffective weapon against troops with shields (Fig. 45). Recent experiments have shown that an arrow fired with a flattish trajectory could penetrate and kill a 'hauberked' man at about 50 yards; or, with a high trajectory, a descending shower of arrows could be sent for some 100 yards. But when confronted by a shield the arrow stuck harmlessly in its surface (Fig. 46).

The shield, of round-topped and so-called 'kite-shaped' form, was probably made of leather-covered wood, and often bore decorative designs such as the wyvern dragon; it was hung by a loose strap round the neck (Fig. 8) when riding into battle with the lance: in close combat, the left arm was placed through two other straps, and the left hand grasped the reins. This type of shield also provided highly effective protection for the infantry, when it was overlapped with others to form the well-known 'shield-wall' (Fig. 46). One or two round shields are also shown in the Tapestry, but they do not seem to have been typical of the general equipment of the two armies.

The chief item of armour worn by all the fighting men, except for some of the archers, was the hauberk (pronounced 'hoe-birk'). By the eleventh century, the hauberk had developed into a tunic of mail – called chain-mail today – with elbow-length sleeves, but open at the bottom like a shirt, worn over close-fitting underclothes. The knee-length leg-portions would have been closed in around the legs by tapes; there were no 'trouser legs', as is suggested by some of the examples in the Tapestry, because the garment could not have been put on or taken off, and it would have been virtually impossible to ride in, with the mail in

the crotch. The hauberk was slipped on or off over the head like an old-fashioned night-shirt (Fig. 50). Some of the hauberks are shown with a patch-like area over the breast; this was almost certainly reinforced, or double thickness, mail to act as a breast-plate. Modern reconstructions have shown the hauberk to have weighed about 25–30 pounds. The more important warriors are also shown as wearing mail leggings known as *chausses* (Fig. 34). A separate piece of mail, called the *coif*, was often used to cover the neck and head, with an opening for the face, shaped somewhat like the modern 'balaclava' (Figs. 31, 34): sometimes the coif was joined to the hauberk.

Finally came the conical iron helmet in the form of a curving cone, with a narrow strip of iron generally riveted to the lower rim to protect the nose, called the 'nasal'. These helmets, when being carried about, were generally held by the nasal (Fig. 29).

It will be seen that William (Fig. 34) is wearing 'tabs' at the back of his conical helmet and hauberk, and one can only conclude that these were 'rank-tabs' which would be clearly visible to those riding behind him in battle.

A fully armed and equipped Norman soldier, complete with shield and spear, carried some 45–50 pounds into battle, as compared with the 55 pounds or so carried into action by the modern soldier.

Men's Clothing

The basic male garment was the tunic, either a short above- or below-knee-length garment, which was common to all classes – well shown in Figs. 16, 17, 18, and in the oath-swearing scene (Fig. 24) – and a long version worn by the 'upper classes' (Guy of Ponthieu in Fig. 18), including also Edward the Confessor, Duke William, and Harold when crowned. The sleeves were close-fitting, but the skirt was often split up the front and back – probably wrapped round the upper legs and secured by tapes – to give the 'trousered' appearance so conspicuous on the Norman riders and the dwarf in Fig. 19, and the Englishmen working for the Normans (Fig. 33): this followed the practice with the mail hauberks (see Arms and Armour). Occasionally both a short and long tunic were worn together, as by Harold at his coronation (Fig. 26). Girdles were invariably worn with all tunics.

The more important men are also seen wearing the cloak, cut to a circular pattern, open down the front, and held below the neck – or on the shoulder – by a brooch. These cloaks also came in two sizes, short and long, often worn with great panache. They were sometimes thrown back over the shoulders (Guy of Ponthieu in Fig. 18, Harold in Fig. 24, and the crowned Harold in Fig. 26); and sometimes swivelled round with the brooch on the shoulder, and a fold draped over the chest and left arm (Harold and William in Fig. 21, and Bishop Odo in Fig. 27). Long cloaks are well shown in Fig. 19, then on William and Harold in Fig. 24, Harold crowned in Fig. 26, and William in Fig. 27. Typical short cloaks are seen on the mounted Harold, Guy and William, all in Fig. 20.

It is interesting to note that none of the sleeved so-called 'super-tunics' is to be found in the Tapestry, nor are any girdled cloaks.

Where legwear was concerned, it is impossible to say whether the many woollen stockings shown were in fact tights, or whether the stockings were worn very high with invisible breeches above them (Fig. 33): this also applies to the underclothes of the soldiers. What appear to be leg-bandages are also sometimes in evidence, but it is stockings which pre-dominate.

There is almost no headgear shown in the Tapestry, other than conical helmets and the coifs beneath; in fact I can find only three cases, all of them the so-called 'Phrygian caps': two are on archers in Fig. 36, and the third on a horseman at the end of the Tapestry.

Women's Clothing

Of the four women who appear in the Tapestry, one – in the border – is naked; of the others, one is Edward's Queen, in his death scene (Fig. 26); one is the controversial Ælfgyva (Fig. 21); and the last is the unfortunate mother leading her son from their burning house (Fig. 33). The queen is wearing a veil above a long gown; and Ælfgyva and the mother are each wearing the veil and the super-tunic (or roc) with long sleeves, well shown in Fig. 33.

Hair, Moustaches and Beards

One of the most conspicuous features of the Tapestry is the ugly hair-style adopted by many of the Normans, where the head is shaved bald at the back and almost to the crown (Fig. 19 and many others); this idea is said to have led to people thinking they were priests in disguise; which surely is absurd.

8

Most of the Englishmen – and some Norman horsemen – have close-cropped hair which often looks as if they are wearing berets (Figs. 16, 17 and many others).

Another conspicuous feature is the moustache, and it is interesting to note that though not all the English have moustaches, none of the Normans has one. For some unknown reason there is one group of Englishmen – those marooned on the hillock in Fig. 39 – some of whom wear outsize 'handlebar' moustaches.

Beards are not uncommon in the Tapestry, but the prize for elegance goes to the dwarf holding the horses in Fig. 19. There are some dozen bearded figures to be seen, including King Edward the Confessor, two of the shipwrights (Fig. 28), one of the Norman cooks (Fig. 32), one Englishman on the hillock (Fig. 39), and one of the last horsemen in the Tapestry.

Women and Horses

It is perhaps not too frivolous to suggest that the designer of the Tapestry was a misogynist; or he may have felt that women were an inappropriate admixture for such a secular feudal epic heavy with charges of treachery and perjury, and with scenes of battle and death. But whatever the reason, he neglected the superb design possibilities of the clothed female form which could have been exploited to great advantage in such scenes as Harold's feast at Bosham (Figs. 2, 16), the oath-taking ceremony (Fig. 24), or Harold's coronation (Fig. 26): there is not even one woman among the onlookers at the Coronation, nor is there one in the crowd being frightened by the comet (Fig. 27). Apart from one of the little lewd figures in the border, only three women appear in the entire Tapestry (Figs. 12, 13, 33). But when it comes to horses, the designer is enthusiastically at his ease – one might even say obsessed – his talent is given full rein, and horses abound from start to finish of the story; they almost completely monopolize the battle scenes: no Norman infantry are to be seen, and only a handful of archers. We can at least be grateful for the mastery of design and execution which the horse-prone designer displays.

The Inscriptions on the Tapestry

There are fifty-seven Latin inscriptions embroidered above the Tapestry scenes, a few of which comprise only a word or two. The translations of these inscriptions will be found above the illustrations that follow, as near as possible to the Latin originals.

Scenes shown in Reverse Order in the Tapestry

A minor, but insoluble, problem has always been those two sections of the Tapestry in which the scenes are shown in reverse order. One is shown in Fig. 19, where we first see the messengers from Duke William arriving to demand the release of Harold from Count Guy of Ponthieu; followed by the same pair of messengers *en route* to Count Guy; and then the escaped Englishman reporting Harold's capture to William. There seems no point at all in this reversal, except possibly in the eye of the designer, who may have thought that the reversal would be pictorially advantageous; this seems a poor explanation, but none other has yet been convincingly advanced.

The other case is in Figs. 25 and 26, where we see the allegedly ailing Edward the Confessor welcoming Harold back from Normandy; then the completion of the new Westminster Abbey; next, Edward's funeral procession to the Abbey; and lastly the illness and death of Edward. In this instance the reason could have been that the designer did not want to show Westminster Abbey alongside the crowning of Harold; and, for some curious reason, the reversal in these scenes does not irk the viewer in the same way as the previous reversal seems to do. But neither case can be solved today, and they stand as interesting conundrums.

Ill-Executed Figures

I have always been somewhat surprised to find a few 'bungled' figures among so much brilliance of design and execution; but there are such items, and we should, I think, have a look at them. To make certain that they cannot be laid at the door of the nineteenth-century restorers, I have compared them with Stothard's engraving, and find they are all there, and have obviously been there all the time. In my lectures on the Tapestry I generally credit these scenes, for light (?) relief, to what I call a 'week-end embroideress'; and although this is, of course, a purely frivolous aside, there may be at least a grain of truth in it. Odo was probably a hard task-master, and the overseer of the work might have pressed into service an embroideress who was not quite up to standard, only to find that at the end of the

job it would take too long to correct the results of such labour; and it is interesting to see that they all occur late in the Tapestry, as if a contract date was fast approaching. But be that as it may, there occur these three bad spots in the Tapestry.

The first is in Fig. 29, where the whole group of horsemen, led by William, is very badly executed, with William a quite inadequately realized figure when compared with renderings elsewhere; and the figure bringing up the rear is quite dreadful, with the rider sitting somewhere half-way through the horse's body.

The second occurs in Fig. 33 where the old bearded man sitting next to Odo and William has his elbow almost hitting William in the jaw, the bent arm paralleling almost exactly that of William himself. It looks as if something went wrong here with the original 'cartoon' on the linen, and that only one such arm should have been included; then the embroideress simply followed the two arms, without thinking.

The third will be found in Fig. 42 (in the centre in the top section) where a Norman horseman brings his sword down on an Englishman's shoulder. If you look at the horseman, he is not only virtually standing on the ground, with his crotch half-way through the horse's neck, but his right (far-side) leg appears *between* the horse's front legs! This must have been a botched job from the start, like the first example, and it was too late to do anything about it when discovered.

THE STORY

WHY HAROLD WENT TO NORMANDY

During the reign of Cnut of Denmark, who died in 1035, Edward the Confessor took refuge in Normandy, and returned to England in 1041. He became King Edward I of England on Hardicanute's death in 1042. But despite Edward's affection for the Normans, and his appointing many of them to Court and other offices, the most powerful influence in England became that of Godwine, Earl of Wessex – and Harold's father – who also led the opposition to the Norman influence at Court. In 1045 Edward married Godwine's daughter Edith. But in 1051 the struggle for power went temporarily against Godwine, and he and Harold were exiled. In this year Duke William of Normandy, to whose family Edward owed so much, paid a friendly visit to England, accompanied by many of his followers. The Norman chroniclers say it was at this time that Edward gave William a formal promise that, at his death, he would succeed him as King of England. It is possible that Edward did make such a promise, in view of his regard for all things Norman.

But in the very next year, 1052, Godwine and Harold made a violent and triumphant return to England. Godwine demanded and obtained the dismissal of most of the hated Normans from their official positions; and, from then onwards, he became the supreme influence in English affairs. Godwine died in 1053, and was succeeded as Earl of Wessex by his son Harold. As Professor Stenton has said, 'for the next thirteen years, the central theme of English history is the rise of Harold to a position which enabled him to secure recognition as king when Edward the Confessor died'. Indeed, Harold attained a quasi-royal status, and became by far the most powerful noble in the land.

Then, probably in 1064, he made a journey to Normandy; and the vital question naturally arises: Why did he go?

The only contemporaries who wrote on the subject were the sycophantic followers of Duke William: William of Jumièges and William of Poitiers. The former tells us that Harold was sent by King Edward to renew the promise of the English Crown made to William by Edward in 1051; and the latter says that, as Edward felt death coming upon him, he wanted his promise to William to be confirmed. The measure of such writers may be taken when it is realized that, when Harold went to Normandy, Edward was in perfect health, and remained so till the end of 1065 when he suddenly became ill; he died on 5 January 1066. There is, of course, no earthly reason why the slightest credence should be given to either of these writers, as both were simply propagandists for William.

The whole drive behind the Tapestry – which was designed to Norman orders – is based on the two Williams' proposition that Harold went to Normandy intentionally as an

'ambassador' of Edward the Confessor, to promise the throne of England to William on the death of Edward.

There is no shred of evidence that Harold ever went intentionally to Normandy for any purpose, let alone to offer the Crown to William; and every reason to believe that he went there only by accident. Here are the main considerations: (1) Harold was the most powerful noble in England after the King, with quasi-royal status; (2) Harold had only to wait patiently for Edward to die in order automatically to succeed to the throne; (3) Harold, like his father Earl Godwine, regarded the Normans as his arch-enemies; (4) Edward had no power to send Harold to Normandy; (5) there is no evidence that Edward in his later years wanted William to succeed him, and Edward had done nothing to decrease or undermine Harold's status and power in the land; (6) Edward was in excellent health, and had no reason to think his end was near when Harold went to Normandy; (7) to suppose, in these circumstances, that Harold would intentionally put himself in the power of his only rival – who would have had no compunction in eliminating him – would be naive in the extreme.

There are, in addition, two significant clues, or 'give-aways', contained in the Tapestry, pointing to the purely accidental nature of Harold's presence in Normandy in 1064: (a) Harold is shown landing in Ponthieu on the *north* bank of the Somme – far from Normandy – in the territory of Guy, a notoriously ruthless vassal of William's. If he had intended to go to Normandy, Harold would have waited for favourable weather and set sail for the far more southerly mouth of the River Seine, on which river lay William's capital of Rouen. Even if a storm had blown up when he was half-way across, Harold could not have failed to reach some part of the very extensive coast-line of Normandy, and thence travel inland; (b) if Harold had gone as Edward's 'ambassador' to William to offer him the Crown, the very last thing William would have done, or Harold agreed to – in view of Harold's status – would be to have him swear an oath of allegiance, which forms one of the key scenes in the Tapestry; such oath-demanding could only be the behaviour of an unfriendly ruler into whose hands fate had thrown his rival; such a ruler would then have to decide what action would most ease his path to conquest; *i.e.* either to kill him and risk enmity and wholesale opposition in England, which would make a costly invasion necessary; or to get England's leading noble on to his side by a combination of friendliness, blackmail and oath-swearing, and thus smooth the way for a peaceful take-over when Edward the Confessor died. The latter course would obviously be the most desirable.

For his part, Harold – when he found himself a prisoner – could only decide to curry favour with William by agreeing to take an oath of allegiance to him; as this oath would be taken virtually under duress, Harold would certainly not consider it morally binding; after all, both for his own and his country's sake, it was obviously incumbent on him to save his own skin at all costs.

No writer has ever advanced a convincing reason for Harold's behaving as the Tapestry and the Norman chroniclers want us to think he behaved. The only so-called 'evidence' are the accounts of the two Williams, of Poitiers and Jumièges; and the fact that they were contemporaries carries no weight at all in view of their position as William's faithful disciples, and of the overwhelming evidence to the contrary.

There remains the question of what Harold was intending to do when he sailed from Bosham. The possibilities are that (i) he was on a voyage to London, or to Flanders; (ii) he was on a fishing expedition in the Channel; or (iii) the most probable explanation, he was on a hunting expedition, for which he intended to land farther up the coast of what is now Sussex or Kent. The last would have taken him up Channel to the narrow area in which he could easily have been blown across to Ponthieu if a bad storm had broken on him.

Whatever Harold's intentions, it must remain perfectly obvious that the one thing Harold did not intend, on that unlucky day, was to land anywhere in France, let alone in Normandy.

THE GIVING OF ARMS TO HAROLD

In Figs. 9, 24, William is seen rewarding Harold for his services on the Brittany expedition by 'giving him arms'; this is not the equivalent to knighting him as has been said – Harold was already an Earl – but a symbolic presentation in which the receiver was thereafter held to be the giver's man, *i.e.* William's man. The Tapestry story thus nears its first climax in showing William deliberately binding Harold closer to him, even to the extent of making him a vassal.

HAROLD'S OATH OF ALLEGIANCE

The first climax of the story is shown in Fig. 24 as Harold takes an oath of allegiance to William, an event which would have been unthinkable if Harold had been sent by Edward as an 'ambassador' to offer the succession to William: the scene only makes sense in the context of Harold's having gone to France by accident, and now being obliged to do anything that is demanded of him in order to save his life. The ceremony is shown here as happening at Bayeux, although William of Poitiers gives the location of the oath-taking as Bonneville-sur-Touques. The ceremony apparently takes place in the open. William sits on an elaborate cushioned throne, while Harold stands between two shrines, touching each as he swears. The shrine on the left is a portable altar incorporating a reliquary, probably carried by William on his campaigns, that on the right probably being a reliquary on a stand. The latter would contain the relics of Saints Rasyphus and Ravennus, two British saints who fled to France and were ultimately martyred there. The two figures on the right are curious: they are possibly meant for Harold's English attendants, despite the lack of moustaches, as neither has the shaved head so consistently given to Normans till now. A later tradition holds that Harold is here seen being tricked into swearing on hidden reliquaries, whilst the man on the right gestures him to caution; but this story misreads an essential point which the Tapestry is bent on demonstrating: *i.e.* that Harold *knowingly* swore on relics and then went back on his oath in accepting the English Crown, thus committing both perjury and blasphemy.

HALLEY'S COMET

The curious-looking heavenly body that is seen speeding through the upper border in Fig. 27 is Halley's Comet, the most famous comet of all time, which visits our sun at intervals of 75–77 years; it last appeared in 1910, and after travelling into the depths of outer space, will again visit us early in 1984. Halley's Comet, which was first recorded by the Chinese in 240 B.C., was pressed into service by the designer of the Tapestry as an omen of disaster for Harold at his Coronation on 6 January 1066, although it is now known that the comet did not reach sufficient brightness to frighten people until March or April, when it appeared in 1066. It first became clearly visible in England in February 1066; it reached perihelion (its nearest position to the sun) about 27 March; it attained maximum brightness late in April; and was lost to view in mid-May.

THE SHIPS AND INVASION FLEET

Both Norman and British ships at this time were in all essentials the 'double-ender' Viking ships of the ninth and tenth centuries, propelled by sail and oars. These efficient and very graceful sea-going vessels varied in length, from about 80 feet to 140 feet, with a breadth of 16 to 28 feet, and pulled anything from sixteen to thirty oars a side. They were clinker-built (overlapping planks) with oar-ports cut in the sides, and equipped with a single mast, stayed fore and aft, fitted with shrouds, and set amidships; each ship had a single decorated square sail, always shown in the Tapestry as bellied out in an attractive design convention. Steering was by means of a rudder (of the steering-oar type), which was not held free, as is sometimes said, but was fixed and pivoted on a chock on the starboard quarter, with an athwart-ship tiller (*i.e.* fixed to it at right angles): this is carefully portrayed in a number of the ships, and is most clearly seen in Figs. 17 and 29: even the point of attachment is clearly shown once (Fig. 17). These long ships – necessarily foreshortened and rendered far from graceful by the designer of the Tapestry – could, under favourable conditions, tack against the wind not closer than six points, thanks to the introduction by the Vikings of a spar-bowline; but tacking would not be risked in fleet formations. Viking ships generally carried 'dinghies' on board, and it is interesting to see one being towed (Fig. 17), although none is shown in the invasion fleet. The ships are also equipped with a 'modern' type of anchor, complete with stock and flukes (Fig. 17). The three small ships seen in the background of Fig. 30 are not, I think, intended to denote smaller-sized vessels, but are put in to increase the mass effect of the fleet.

When armed troops are on board, their shields are seen arranged overlapping along the gunwales (see Figs. 17, 25, 30): but this is certainly a technical error on the part of the designer, based on insufficient knowledge of the sea. It is well known and documented that in the Viking ships – and the same rule would apply here – shields were only allowed to be displayed along the gunwales when in port. Before the ship was got under way, they were stowed elsewhere on board for the good reason that their position along the gunwales would interfere with the seamen who had to man the oars, as they would have to be prepared to do at any minute with the limited navigational facilities of the single square sail, as well as when leaving and entering port.

In any case, the designer was even more at fault in the arrangement of the shields *inside* the gunwale, where they could not be properly fixed: when displayed, they were always fixed outside the gunwales so that their bottom halves acted like flanges and were pulled tight against the ship's side by the fastenings on the insides of the shields.

The curious placing of shields (or shield-like structures) at bow and stern (Figs. 17, 29, 30) may be a form of the ancient 'aphlaston', or anti-ramming protection. Stem and sternpost heads are often elaborately carved, the most outstanding being on the sternpost of the flagship *Mora* (Fig. 30), where a horn-blowing figure holds out a miniature lance and gonfanon. Five of the ships in the Tapestry fly pennons (or pennoncels) at their mastheads; but the large object at the masthead of the *Mora*, beneath the cross, is the signal lantern which was lit as a starting signal for the fleet to proceed across the Channel. An old and curious tradition held that this was the sacred Papal banner: needless to say, the Papal banner would under no circumstances be exposed to the elements by being attached to the masthead. William's flagship, the *Mora*, is a magnificent vessel, presented to him by his wife Matilda, who also paid for its fitting out (Fig. 30).

William's invasion of England involved, for that time, a gigantic military operation. He had assembled – so it is now estimated – about 7,000 men, of whom some two thousand may have been mounted. This army was a polyglot assemblage consisting of Normans, Bretons, Flemings, Frenchmen from other parts of France, and even some Italians and Sicilians. The hard core was, of course, Norman, with sympathizers and mercenaries swelling the numbers. This multitude needed a large navy. William of Jumièges says there were three thousand ships, and he may well be right. As it is not known which size of Viking-type ships were built and used, it is now impossible to make a closer estimate. Very few of the necessary ships would have been already available; so between January and August of 1066 a formidable building programme was carried out.

The expedition was planned to sail from a point off the mouth of the little River Dives. The twelfth August found the fleet assembled there, and in nearby harbours, waiting for a favourable wind from the south: but that wind did not blow: instead, after waiting a month, a storm broke from the west on 12 September, and the fleet was forced to sail up the coast with losses by weather and desertion en route. The ships then anchored at the mouth of the River Somme, off St. Valéry, where they had another enforced wait. At last, on 27 September, a favourable wind began to blow. William ordered the fleet to put to sea, but to anchor just off shore and wait for nightfall. Then, when the signal lantern was lit at the masthead of William's flagship the *Mora* (Fig. 30), the fleet weighed anchor and made the crossing in darkness. The ships arrived safely in Pevensey Bay during the morning of Thursday, 28 September 1066.

THE PAPAL BANNER

There has been in the past some controversy about the identification of the gonfanon banner which Pope Alexander II had blessed and presented to William. It has even been said that the half-moon pennon, with short tails around the edge (seen in Fig. 34), was the Papal Banner; but this was simply a pennon derived from the Norse raven battle-flag, and the form of a bird is clearly visible on it. Apart from anything else, the Papal Banner would under no circumstances be carried couched: it would always be held upright. Dodwell makes the surprising statement that the Papal banner 'is not represented in the Bayeux tapestry', basing his view on that of Prof. Carl Erdmann (in his *Die Entstehung des Kreuzzugsgedankens*, Stuttgart, 1935). I suggest that it is indeed shown, and shown twice, in the Tapestry, and this view is shared by Mr. Galbraith (see below). Like so many other items, the rendering would not pretend to any accuracy; but the way this particular banner is singled out for special treatment (Figs. 33 and Fig. 39) suggests it is intended for the Papal Banner. In

Fig. 39 it is carried into battle by Eustace of Boulogne; it waves bravely in the upper border, bearing a cross, and its three long tails are given decoratively conventional knot-like twists. It has been said that Turstin de Bec carried the Banner in the battle, but there is no evidence for this. A discussion of the Papal Banner will be found in D. L. Galbraith's *Papal Heraldry* (Cambridge, 1930).

THE BATTLE OF HASTINGS

The Tapestry displays, with great vigour and beauty, the Battle of Hastings. But it is, with a few exceptions, a highly stylized battle, and bears little relation to the actual events of the real battle. Paul Johnstone of the B.B.C. drew upon historical and military advice for a reconstruction of the battle he produced some years ago, and it is the script of his authoritative television broadcast that I gratefully summarize here.

Harold had force-marched from York – 250 miles in under twelve days – and had bivouacked for the night of 13 October 1066, on a ridge (now called Battle) some six miles north-west of Hastings, intending to make a surprise attack on William in the morning. But William's military intelligence was excellent, and he had been well advised of Harold's movements: so he had moved out of Hastings early on the morning of 14 October, intent upon forcing a defensive battle on Harold, which he succeeded in doing. Harold soon discovered that the Normans were on the move and decided to remain where he was: he had at least the advantage of holding high ground. So he deployed his troops – all infantry – along an 800-yard front on the ridge; his army numbered about 7,000 – approximately the same figure as the Normans – but he had no cavalry, and only a handful of archers. In front he placed about 1,000 'huscarles', some of the finest troops in Europe, and they were ordered to line up in close order, and form the famous and formidable 'shield-wall' (see Fig. 46). His soldiers were armed not only with conical helmets, hauberks, swords, shields and spears – like the Normans – but also with the great so-called Danish battle-axe, a weapon that does not appear to have been used by the Normans. After reconnaissance from Telham Hill, William drew up his army below and facing the ridge, and about 150 yards from Harold's lines. His polyglot army was composed of archers, infantry and cavalry, all in strength, the great advantage lying with the cavalry, of which he may have had as many as 2,000.

The battle started at about 9.30 on the morning of 14 October, and divided itself – with long intervals – into four clear-cut phases, the initiative necessarily resting with William throughout. First of all, William ordered an 'artillery' attack by his archers, who advanced and let fly (for details of the bows, etc., see page 7); but this had no effect on the English shield-wall, and the archers withdrew.

Secondly, William ordered a full-scale infantry attack, and this nearly brought disaster to his army: for the Bretons on the left flank were repulsed and badly beaten, took to flight, and found themselves pursued downhill – against Harold's orders – by the English sections opposing them. Panic started and spread to the rest of the Norman army, and a rumour also spread that William had been killed. It was in order to stem this panic, stop the rumour, and rally his troops, that William pushed up his helmet (as seen in Fig. 39) and rode amongst them to show his face: this move not only succeeded, but William then led his cavalry against the unwisely pursuing English – who could not regain their hillside positions – cut them off, and annihilated them. A last stand was made by these disobedient pursuers on a small hillock which is clearly identifiable on the battlefield today and is seen in the Tapestry (also in Fig. 39).

Thirdly, William mounted a full scale cavalry attack; but, even against Harold's depleted force, it failed hopelessly, and resulted in the head-long retreat of the Norman horsemen: the old theory that William made this attack as a feint is now ruled out by military historians; nevertheless, the English again disobeyed orders and pursued them downhill; again they were cut off by William's army and annihilated, thus reducing Harold's forces to a critical degree. The armies had now been fighting for eight hours and the light was starting to fail.

Fourthly, and finally, William mounted a combined forces attack, with archers giving high-trajectory covering fire, followed by waves of infantry, and then by the cavalry. The sheer weight of this attack at last breached the English shield-wall, and the Normans broke through. Harold and his two brothers were killed, and the English army was broken: the Normans pursued them, but the onset of darkness and the wooded terrain allowed the remnants of Harold's army to escape. Such was the sequence of events on that historic and fateful day.

Harold was not hit in the eye during the Battle of Hastings; nor does the Tapestry show him being hit in the eye. He was hacked down by Norman knights.

The first mention in history of Harold being hit in the eye was made long after the battle, between 1099 and 1102 in a poem by Baudri, Abbot of Bourgueil; and even he was not writing of the battle as such. He was actually describing a stretch of embroidery, probably similar to the Bayeux Tapestry, which hung round the bedchamber of Adela, Countess of Blois. From this story, the belief in the arrow-in-the-eye story grew and prospered until it became so-called 'history'. There is no historical evidence for it at all.

Now for the Tapestry. Today, if one looks at the relevant section (Fig. 42), the arrow is not shown piercing Harold's eye; and it was never intended to pierce it. The restorers in the last century have deliberately bent the arrow – as far as they felt they could – to make it look, at a superficial glance, as if it were going in Harold's eye, because they were all brought up in the traditional belief that he was thus hit. But fortunately we have an accurate drawing of what the Tapestry originally showed, because the English scholar C. A. Stothard – who went over to study and copy the Tapestry in the Regency – has left us a true record in *The Bayeux Tapestry* (London, 1819). When Stothard surveyed it, many of the woollen threads had been worn right away; and when he encountered this, he carefully marked in the stitch-holes to show where the original threads had been; and we can see with great clarity where that arrow originally went. As shown in the detail above Fig. 54, the arrow went right up to the rim of his conical helmet. The restorers did their best, as I said, to bend it in towards the face, but one can still see the stitch-holes in which the threads should have been replaced. It is interesting to note that in the crudely drawn and engraved illustrations of the Tapestry in Montfaucon (1730) and in Ducarel (1767), the arrow is also shown going nowhere near the eye of the figure.

Apart from this conclusive evidence, there are other points to be noted. Subsequent writers have presumably been influenced by the fact that Harold's name appears over the figure hit by the arrow. This has no significance at all. The reason for the name being above that figure is that the designer was faced with a very small space in which to place the inscription for Harold's real death scene, which is next door, where he is being hacked down by a Norman knight. Owing to the height of the group of figures beyond Harold's death-scene, there was no room to spread the inscription to the right; and so it had to be spread to the left, in order to get it all in, and to finish it on the right scene; which the designer only just manages even now, with the word INTERFECTUS divided. It is pure chance that the name Harold appears where it does. This inevitably happened where the designer had to fit words in as best he could, or the dictates of grammar intervened; this can also be seen in Fig. 29, where the inscription reads: HIC WILLELM DUX IN MAGNO NAVIGIO (etc.), where the name William occurs neither above the figure of the Duke leading his men down to the ships, nor over a ship with William in it.

The next point is that the group containing this so-called figure of Harold is simply the headquarters group of the army, and Harold would never be shown standing *fourth* in line with the others.

Then comes the suggested possibility that Harold is shown both in this figure, and next door being hacked down. But this would go against all the idiom of the Tapestry, to say nothing of the fact that the real figure of Harold is sinking to the ground without an arrow in his eye.

Furthermore, wherever a man is shown in the Tapestry seriously wounded, or being killed, he is never left standing upright; such a figure is always shown falling, sprawling, jack-knifed, bent or doubled up, or otherwise signifying that he is obviously in trouble. The figure in question is standing bolt upright. He has been hit by an arrow, which would probably not be powerful enough to pierce his forehead at that range (see page 7), and he is plucking it away. If the arrow had been meant to be shown actually in his forehead, the figure would be shown falling or reeling.

Incidentally, if the Tapestry wishes to show a man hit in or near the eye, it makes it quite clear what is intended, as is seen in Figs. 42 and 49.

CHRONOLOGY

1022 (?)	Harold is born; he is the second son of Earl Godwine.
1027 (or 1028)	William of Normandy is born at Falaise.
1035	William becomes Duke of Normandy.
c. 1036	Bishop Odo of Bayeux born.
1051	Harold and his father are banished from England, Harold going to Ireland.
1051	William visits England.
1052	Godwine and Harold return to England under arms.
1053	William marries Matilda, daughter of Baldwin V of Flanders.
1053	On Godwine's death, Harold becomes Earl of Wessex.
1063	Harold and Tostig raid Wales.
1064(?)	Harold is probably shipwrecked on the French coast, in the territory of Guy of Ponthieu; he is rescued by William and taken to Rouen.
1064(?)	Harold marries Ealdgyth, widow of Gruffyd of Wales.
1065 (28 Dec.)	The new Westminster Abbey is consecrated.
1066 (5 Jan.)	Edward the Confessor dies.
1066 (6 Jan.)	Harold is crowned at Westminster as King Harold II of England.
1066 (Apr.)	Halley's comet attains maximum brightness to those in England.
1066 (12 Aug.)	The Norman invasion fleet assembles near the mouth of the River Dives.
1066 (Sept.)	The fleet sails north and anchors in the mouth of the River Somme, off St. Valéry.
1066 (25 Sept.)	Harold defeats Hardrada and Tostig at Stamford Bridge.
1066 (27 Sept.)	The Norman invasion fleet sails for England.
1066 (28 Sept.)	The fleet arrives off the English coast, and the army goes ashore at Pevensey.
1066 (14 Oct.)	William defeats Harold at the Battle of Hastings, and Harold is killed.
1066 (25 Dec.)	William is crowned at Westminster as King William I of England.
1067	Bishop Odo is made Earl of Kent; he commissions the Bayeux Tapestry.
c. 1067–70	The embroidery known as the Bayeux Tapestry is made in England.
1077	The new Cathedral at Bayeux is dedicated.
1082	Bishop Odo falls from power and is sent to Rouen, where he is imprisoned.
1087	William dies at Mantes and is buried at Caen; Odo is immediately released and attends the funeral; he then returns to England.
1088	Odo is forced to relinquish his possessions, and flees to France.
1097	Odo dies at Palermo (Sicily) and is buried in Palermo Cathedral.

SELECT BIBLIOGRAPHY

MONTFAUCON, B. DE. *Les Monuments de la Monarchie Française* (Vols. I and II), 5 vols. Paris 1729–33. (English translation: *A Collection of Royal and Ecclesiastical Antiquities of France.* 2 vols. London 1750.)

DUCAREL, A. C. *Anglo-Norman Antiquities considered, etc.* London 1767. (French translation. Caen 1823.)

BAYEUX. *Notice historique sur la Tapisserie brodée de la Reine Mathilde, etc.* Paris 1804. (Another edition Bayeux, 1854.)

STOTHARD, C. A. *The Bayeux Tapestry.* London 1819. The accompanying essay is in *Archaeologia*, XIX (1821), pp. 184–91.

DUCAREL, A. C. *Tapisserie de Bayeux.* Caen 1824.

BRUCE, J. C. *The Bayeux Tapestry elucidated.* London 1856.

LONDON, South Kensington Museum. *Textile Fabrics: a descriptive Catalogue, etc.* By D. Rock, London 1870.

FOWKE, F. R. *The Bayeux Tapestry.* London 1875. (Abridged ed., London 1898.)

DAWSON, C. *The Restorations of the Bayeux Tapestry.* London 1907.

BELLOC, J. H. P. *The Book of the Bayeux Tapestry.* London 1914.

LEVÉ, A. *La Tapisserie de la Reine Mathilde, dite la Tapisserie de Bayeux.* Paris 1919.

LOOMIS, R. S. 'The Origin and Date of the Bayeux Embroidery', *Art Bulletin*, VI (1923).

CHEFNEUX, H. 'Les Fables dans la Tapisserie de Bayeux', *Romania*, LX, nos. 237, 238 (1934).

LEJARD, A. *La Tapisserie de Bayeux. Accompagnée de La Conquête de l'Angleterre par Guillaume le Conquérant, texte extrait de 'La Chronique de Normandie', adaptée par M. Hébert.* Paris 1946.

VERRIER, J. *La Broderie de Bayeux, dite Tapisserie de la Reine Mathilde.* Paris 1946.

MACLAGAN, E. *The Bayeux Tapestry.* (Revised ed.) London 1953.

STENTON, Sir F. (et al.). *The Bayeux Tapestry: a comprehensive Survey.* 2nd ed. London 1965.
The subjects and authors represented in this work are as follows:
The Historical Background: Sir F. Stenton; Style and Design: F. Wormald; Technique and Production: G. W. Digby; Arms and Armour: Sir J. Mann; The Costumes: J. L. Nevinson; The Architecture: R. A. Brown; The History of the Tapestry: S. Bertrand; Notes on the Plates: C. H. Gibbs-Smith.

DENNY, N. and FILMER-SANKEY, J. *The Bayeux Tapestry: . . . the Story of the Norman Conquest, 1066.* London 1966.
The whole tapestry is shown in colour.

BERTRAND, S. *La Tapisserie de Bayeux et la manière de vivre au onzième siècle.* Paris 1966.

DODWELL, C. R. 'The Bayeux Tapestry and the French Secular Epic', *Burlington Magazine*, CVIII (1966).

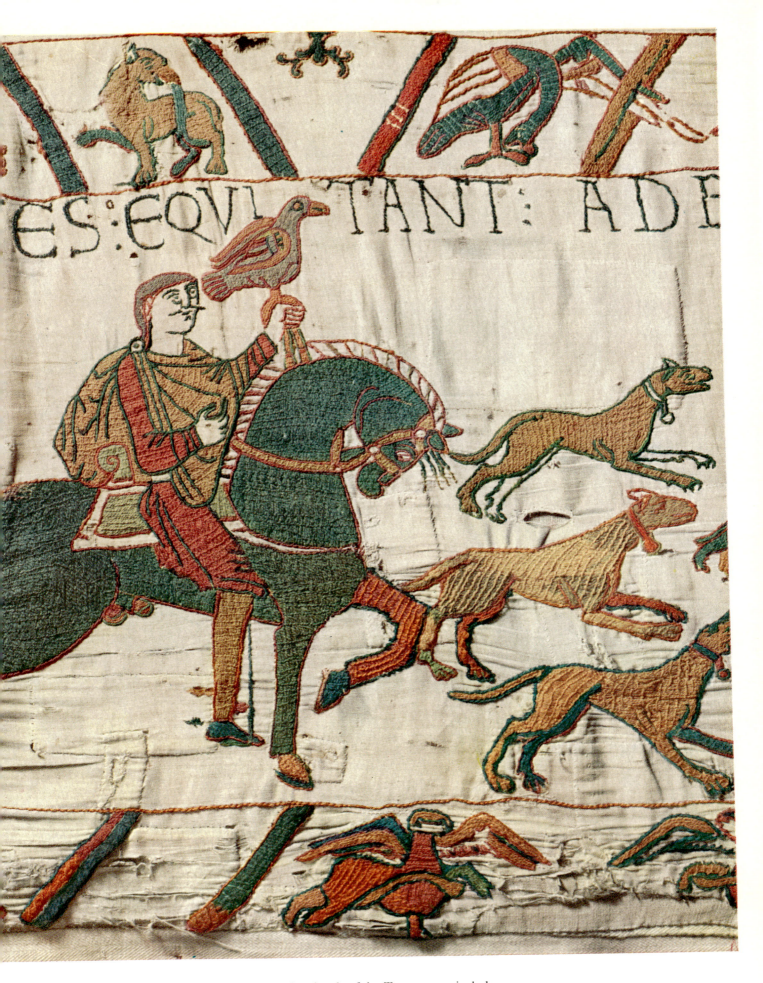

...ES:EQVI...TANT:ADE...

...rold on his way to Bosham. This plate shows the mood and style of the Tapestry particularly ... the fine formalism of the hog-maned horse – with different coloured legs – and its rider; the ...naturalistic hunting dogs; and the almost diagrammatic hawk perched on Harold's hand. Note ...k of a hood on the hawk's head – an item not yet introduced from the Middle East – and the ...ce of the high-peaked saddle, the stirrups and spurs, and the collars of the dogs with their ...rings attached. Harold is seen wearing a short brown tunic beneath an elegant cloak.

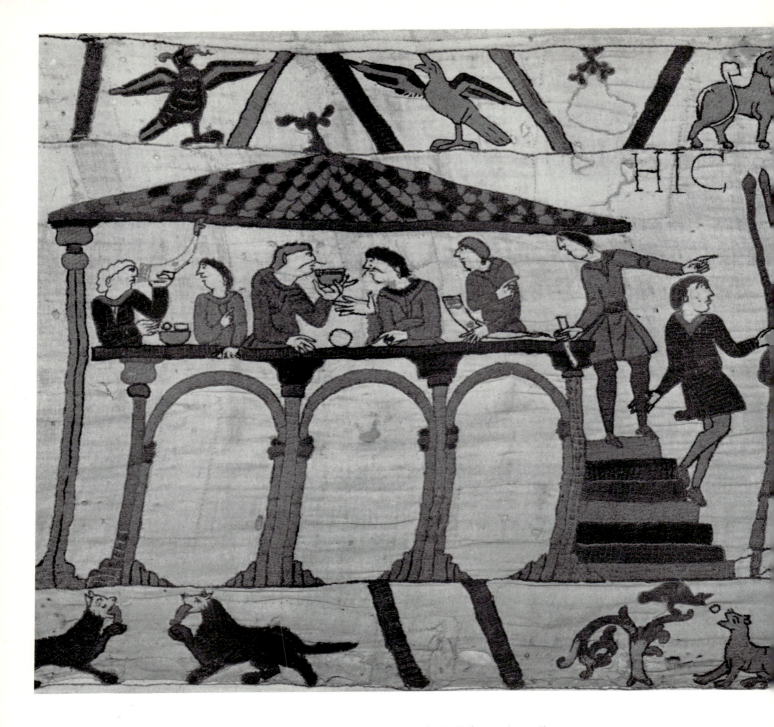

2 The feast in Harold's mansion at Bosham, finely suggested by the roofed building and arcading below. Perhaps the most interesting feature of this scene is the deliberate omission of the right-hand supporting column of the roof in order to smooth out the composition, and attract proper attention to the man announcing that the ship is ready to sail, and pointing to it. Both a bowl and horns are here seen as drinking vessels.

3–5 Sections of the border of the Tapestry. The border comprises various types of figur scenes, including fables, naturalistic scenes from country life, studies of animals and birds, wonderful selection of fabulous and symbolic beasts of all kinds. Here (at the top) is a scene of p ing, with a mule being used instead of a horse or oxen. Next comes a scene of sowing: se being scattered in the wake of a horse-drawn harrow. Then there is a wonderful illustration fable of the lion who is welcoming all the animals under the guidance of the monkey. And bottom) there is a scene of bear-baiting, showing a Norman soldier – note his typical hair-threatening the poor bear, who is muzzled and tied to a tree.

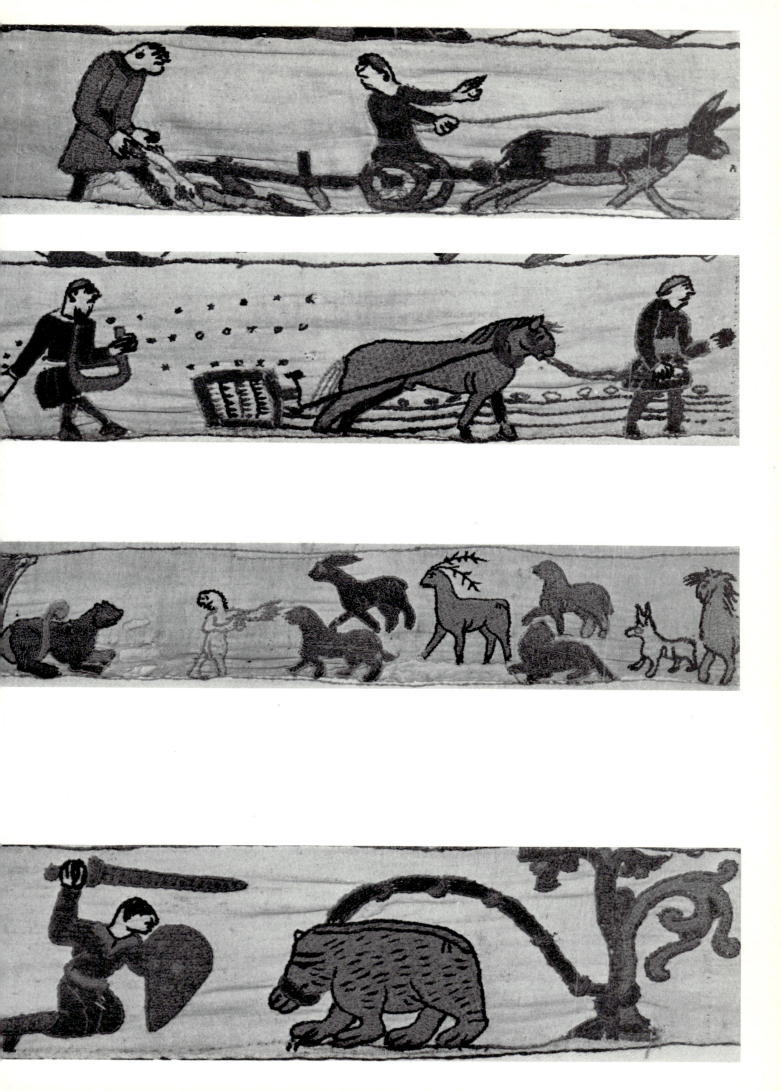

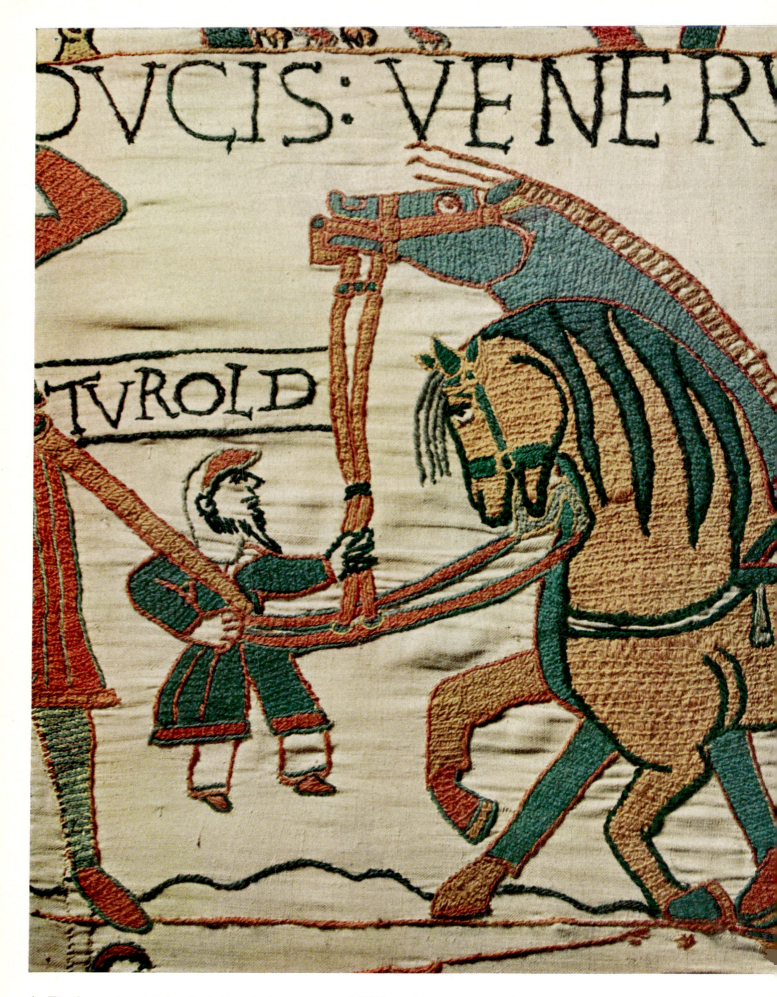

6 The famous bearded dwarf minding the horses on which William's messengers have ridden to secure Harold's release from Count Guy of Ponthieu. It is a splendid study of the two beasts. The dwarf is often thought to be Turold; but that name belongs to the messenger out of sight on the left, who was probably Turold, the son of the Constable of Bayeux, and is mentioned in Domesday Book. The dwarf was claimed by the Victorians to be a self-portrait of the designer of the Tapestry!

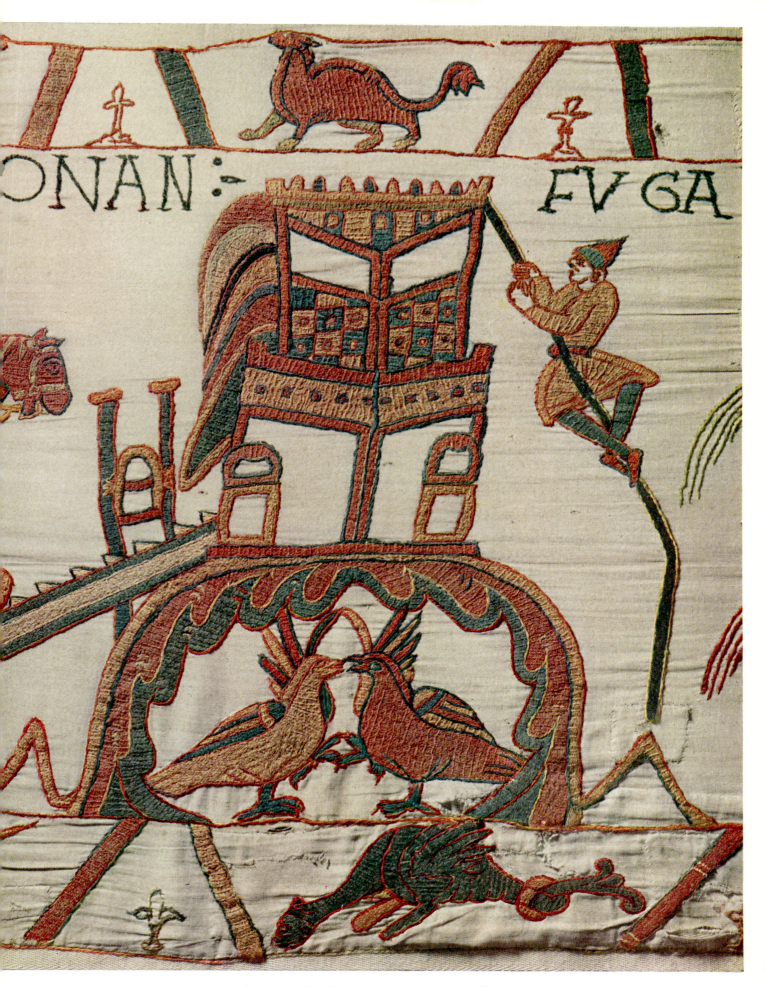

ONAN : FVGA

ount Conan escaping down a rope from the castle at Dol. The Duke is seen dressed in a girdled
, and wearing the so-called 'Phrygian bonnet'. The castle is built on a hill, and the structure
e left – just in front of the horse's nose – is probably meant to represent a drawbridge. Note
wo fabulous birds used as a space-filler beneath the castle, and the equally magnificent wyvern-
dragon on the lower border, with his two legs and customarily knotted tail.

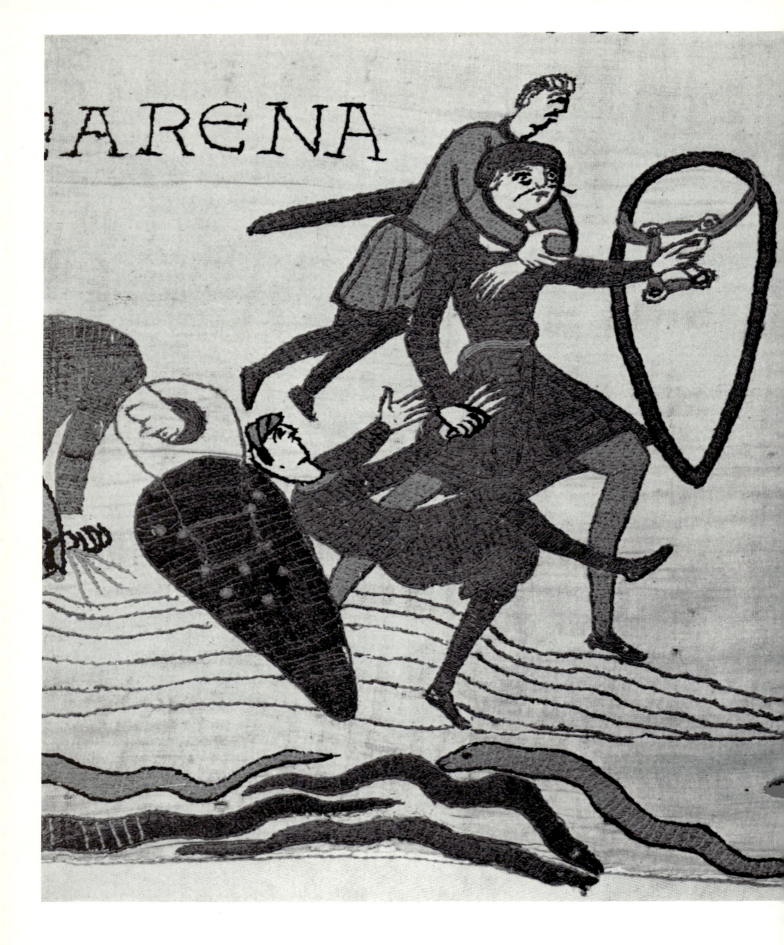

8 One of the key emotional scenes in the Tapestry, where the valiant Harold rescues the Normans from the quicksands at the mouth of the River Couesnon. The incident takes place during the somewhat curious section of the Tapestry dealing with William's military expedition against Count Conan of Brittany. Harold accompanies the expedition and shows such prowess that William later gives him arms (see page 11), and thereby cements the relationship between them. In reality, Harold is obviously doing all he can to ingratiate himself with William in order to get safely out of his predicament.

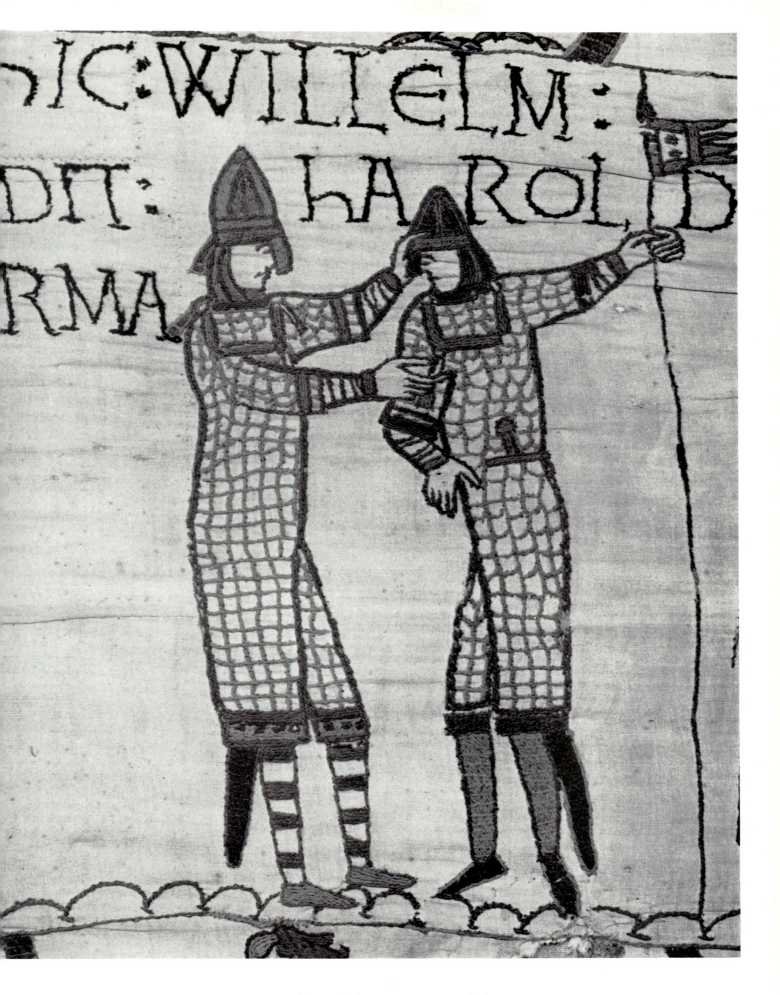

`IC:WILLELM:`
`DIT: HAROLD`
`RMA`

...e William 'gives arms' to Earl Harold after the expedition to Brittany, a ceremony which ...Harold firmly to his host and makes him 'William's man' for ever. The Tapestry seeks to ...ow close the two men became, and that Harold accepts William as his lord and master. Thus ...'s subsequent 'treachery' in accepting the English Throne is made as bad as possible, and a fit ...for William's invasion. Note the 'rank-tabs' at the back of William's neck.

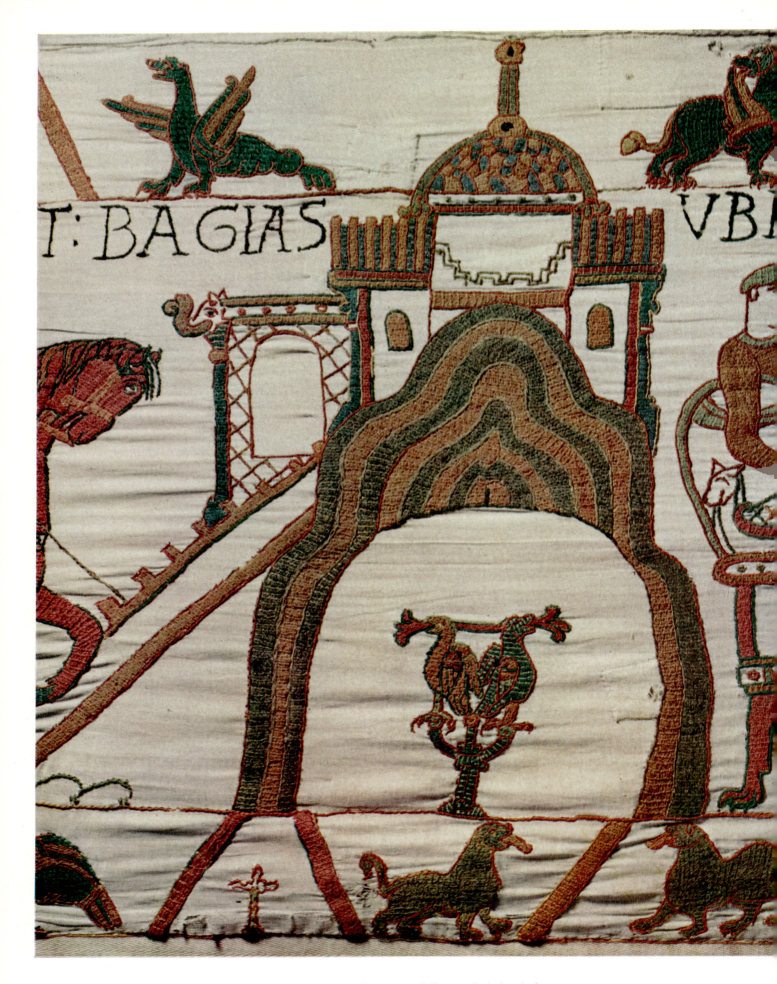

T: BA GIAS UBI

10 The castle of Bayeux. This elegant structure only symbolizes the building, and obviously bears no resemblance to the actual castle at Bayeux. There is a domed tower with an elaborate entrance portico, and the building is shown as on a hill, or high ground, with a steep 'drive' up to it. Below, as a decorative feature, are the customary formalized birds, in this case probably intended for hawks. In the upper border is another fine wyvern-type dragon on the left of the tower; and on the right, a winged beast with clawed feet, possibly a griffin.

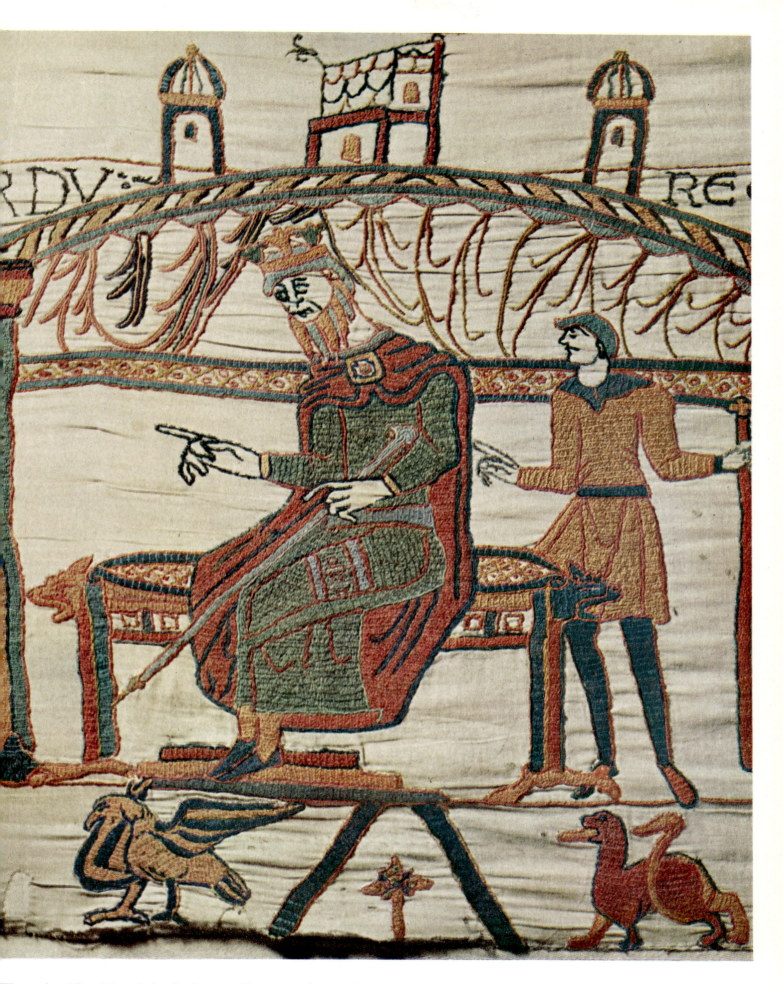

The ageing King Edward the Confessor, with an attendant, as he welcomes Harold home. ...cal of the dishonest story the Tapestry tells is this figure of the King, who is deliberately made ...pear frail and sickly, whereas he was perfectly hale and hearty at the time, and only fell ill ...enly and unexpectedly more than two years later. He should be compared with the figure of ...King in the first scene of the Tapestry, where he is shown as spry and active. But the Tapestry ...ner had to telescope events to suit his purpose.

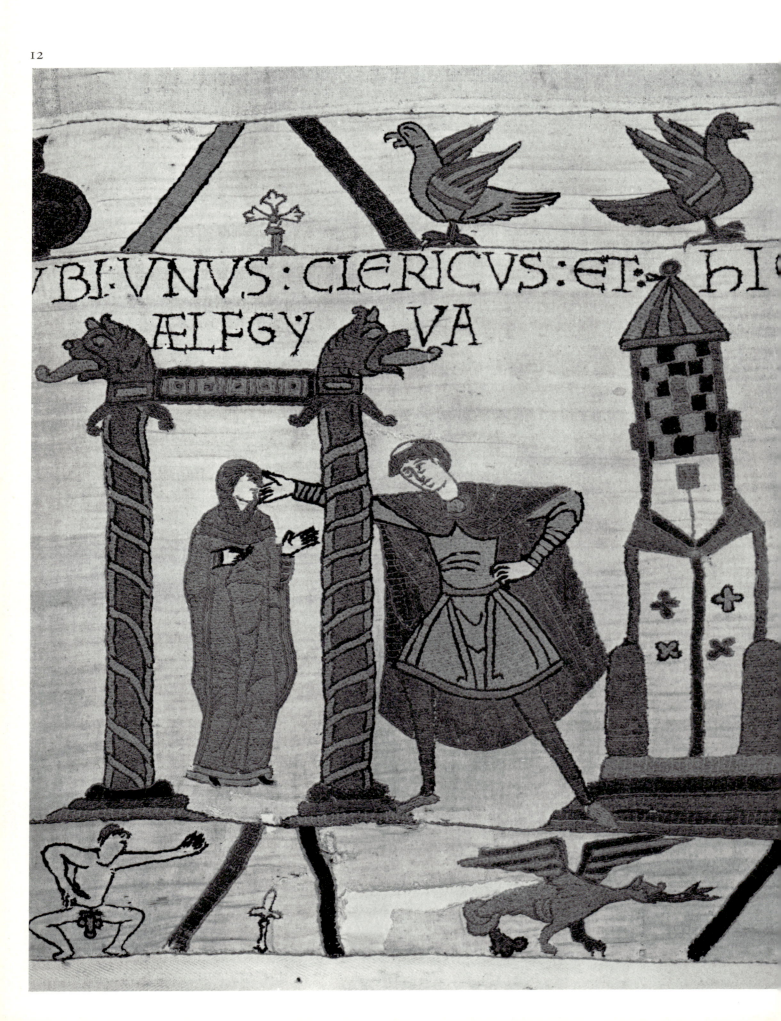

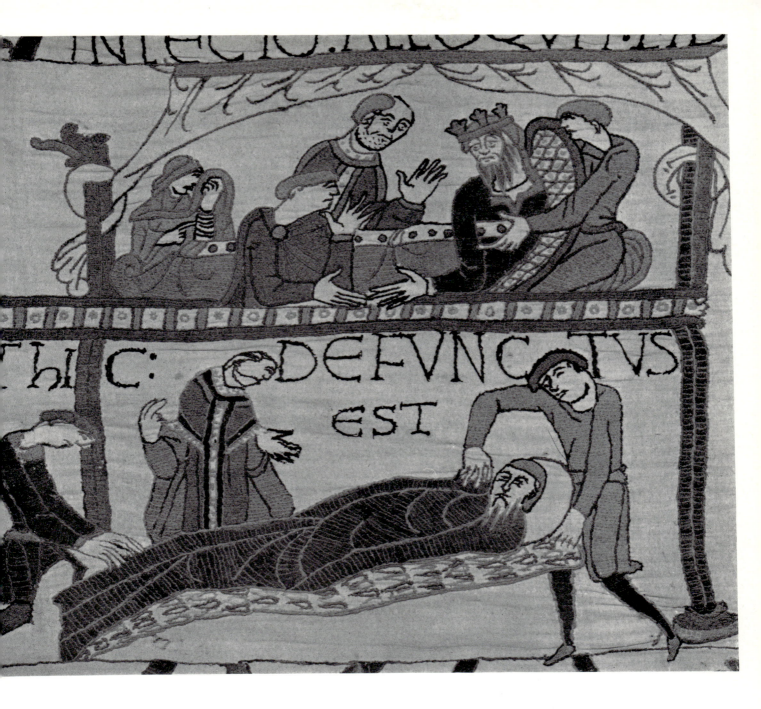

ere are the superposed scenes of Edward the Confessor's last hours, and of his death on
ary 1066. All this is presented in a formalized building, with an interesting textile surround
g the upper scene, which may indicate the hangings of an alcove, or the King's bed. The
supported by possibly Robert the Staller, speaks to Harold; and on the far side of the bed
een Edith – who was Harold's sister – and an ecclesiastic (see below). An interesting feature
scene is the large and elaborate pillow against which the King lies back, patterned in a similar
the cushion in Fig. 16. In the scene below, the dead King is prepared for burial by two
ants, with the ecclesiastic looking on; it may be that the designer intended to represent Arch–
Stigand in both scenes; but it is curious to see that when the Archbishop is introduced by
(Fig. 26), he is shown clean-shaven, whereas here the man is shown bearded.

he inscription over this scene reads: 'where a certain clerk (priest) and Ælfgyva'. There has
much speculation about this famous scene, which is given great prominence in the Tapestry,
ust have been instantly familiar to contemporary viewers. It is interesting to note that the little
man in the border below is making the same gesture – and similarly placing the other hand on
p – as the priest. The woman is seen by her dress to be an 'aristocrat', and was presumably
with the priest in some scandalous relationship, this being the obvious indication by the
ce below of the naked man. Ælfgyva has been described variously and speculatively as William's
ter and Harold's sister, but there is no historical evidence of any kind as to her identity.

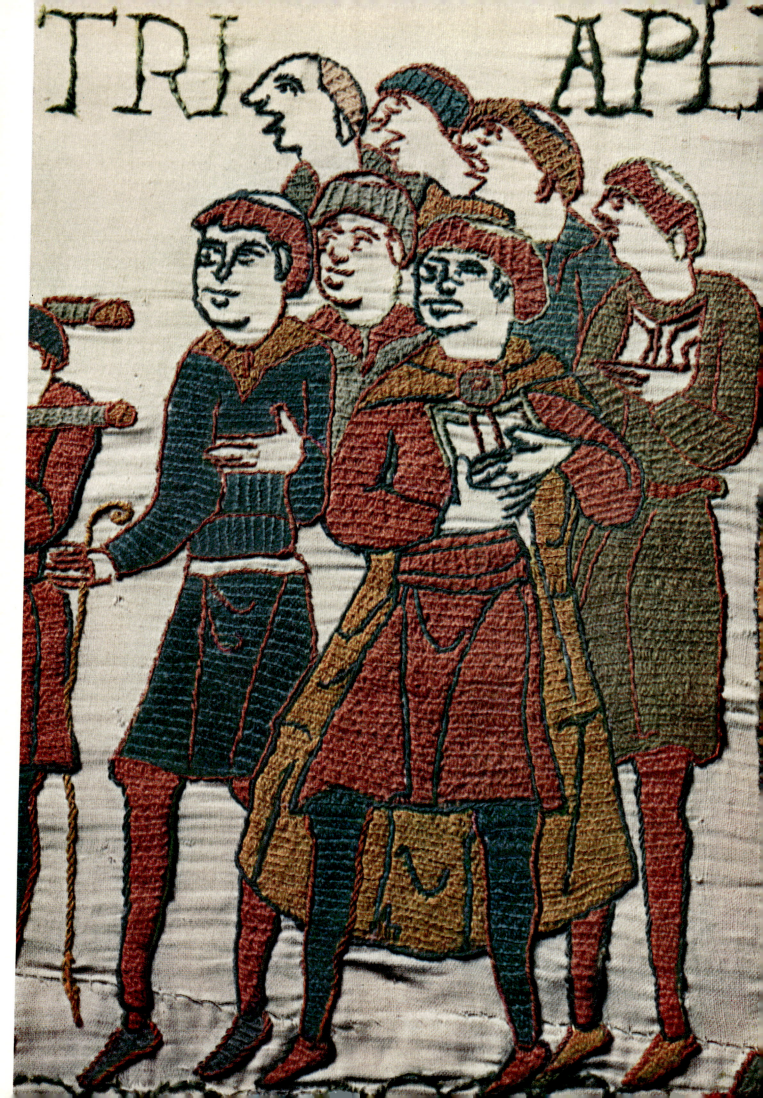

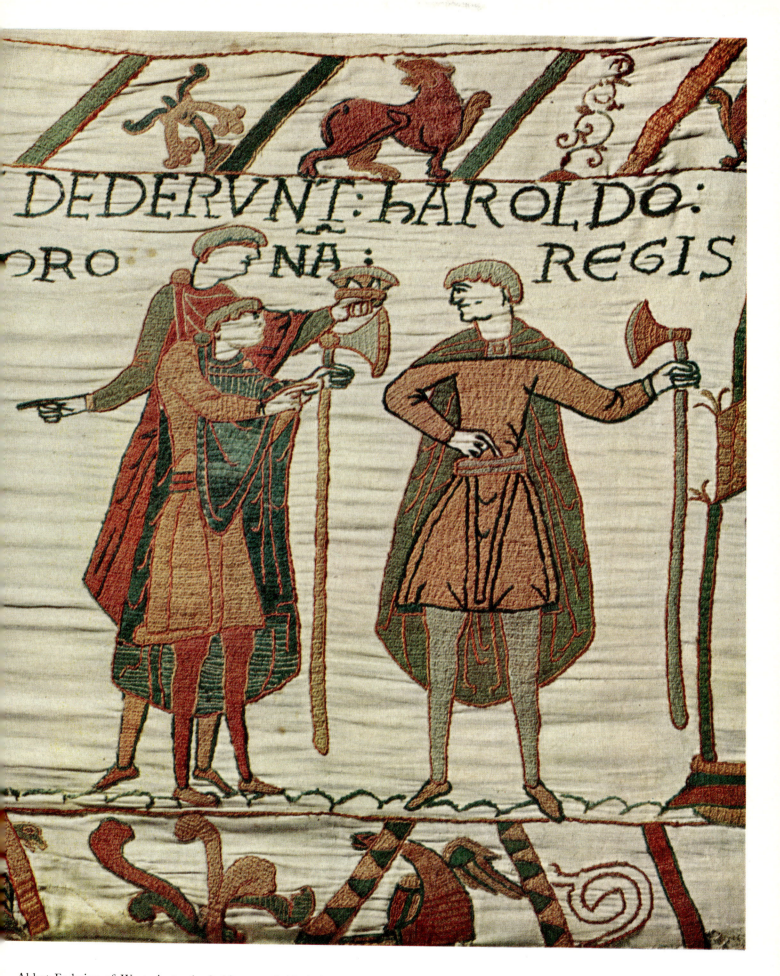

DEDERVNT:HAROLDO:

ORO NA: REGIS

Abbot Eadwine of Westminster leads his party behind the bier at the funeral of Edward
Confessor on 6 January 1066. The King's friend is seen here with his crosier leading the other
ed ecclesiastics at the funeral. Two are carrying open prayer books and those in the back row
ging. Above, the Crown is offered to Earl Harold. This is one of the most elegantly executed
in the Tapestry, and shows the leading nobles of the Witan offering the Kingship of England
old; one of them holds out a crown, the other the official axe, symbol of authority. Harold him-
ries a war-axe.

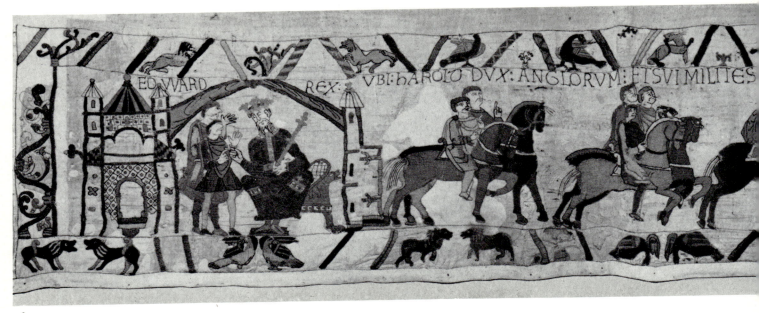

16

16, 17 King Edward the Confessor, presumably in his palace at Westminster, is speaking to Earl Harold of Wessex (the shorter figure); apparently giving instructions to Harold before his journey to France. The year is probably 1064. The King, crowned and holding his sceptre, sits on a cushioned and ornamented throne. The various buildings so charmingly portrayed in the Tapestry – with the possible exception of Westminster Abbey – bear no relation to the actual buildings of the day, the designer indicating only the nature of the structure concerned.

We now see Harold inexplicably leading a hunting party (see Fig. 1 and page 10): he rides in front, holding his hawk on his left wrist, with the dogs running on ahead. This hawk, and the others, appear without hoods, as that item of equipment had not yet been introduced from the Middle East. The horses are hog-maned in the English manner; the riders have high-peaked saddles, and stirrups. Harold alone has spurs. The dogs have collars with leash-rings. The first two scenes of the Tapestry display an important identification feature, in that moustaches are to be seen only on the English: not all the Englishmen wear them, but no Frenchman ever wears one.

Harold and one of his party stop to pray at Bosham Church. Bosham, three and a half miles from Chichester, is on Bosham Channel, an inlet of Chichester Harbour in Sussex, and the manor had been acquired by Harold's father Godwine.

The party feasts at Harold's manor house. One of the party drinks from a horn and Harold drinks from a bowl. On the right a servant gestures that it is time to leave. The house is an interesting type of formal rendering, with arches beneath, a stairway, and the tiled roof unsupported at one end for compositional purposes.

17

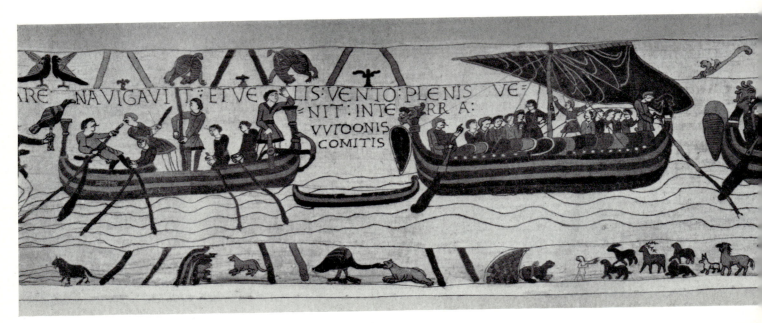

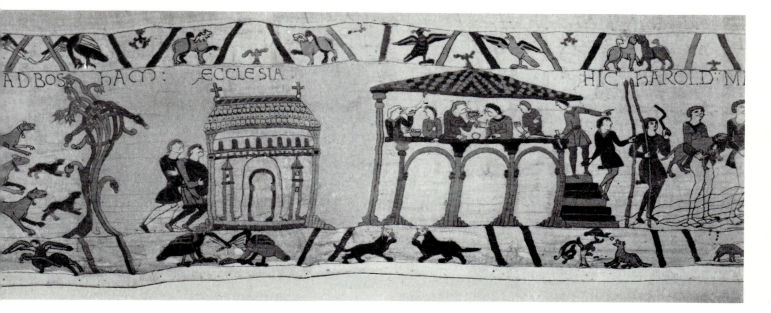

The party, carrying hawk and hounds, wade out to their ship, which is then seen being got under way with poles and oars. Only one ship takes part in the Channel crossing, despite variations in its rendering (for a note on the ships, see page 12). This first ship is of particular interest, as it shows the mast being stepped, the anchor with stock and flukes, and the horizontal tiller of the rudder. The designer has omitted the necessary oar-ports but has included them in the next drawing. The angled object seen in the man's hand (far right, Fig. 16) is possibly a leash, certainly not a boomerang as has been suggested.

Now under full sail, and towing its 'dinghy', the ship bears the party across the Channel. This is the first occasion on which the main scenes 'invade' the border. A curious feature here is the row of overlapping shields along the gunwale (see note on the ships). The oar-ports are clearly shown here. The stern shield is also discussed in the note.

The ship then approaches the French coast: a look-out is clinging to the mast-head; the crew are manning ropes and poles; one of them (in front of the mast) tests the depth of water with the sounding lead; and a man in the bow holds the anchor ready for dropping: the oar-ports are omitted again, but the rudder hinge is clearly shown. The ship arrives, and is almost emptied, with the anchor rope running ashore. The figure in the bow is generally taken to be Harold, who is now armed with a spear. The scene takes place on the north shore of the mouth of the River Somme, in the domain of Count Guy of Ponthieu, a ruthless vassal of Duke William of Normandy.

(OF PONTHIEU): HAROLD: HERE GUY SEIZES HAROLD:

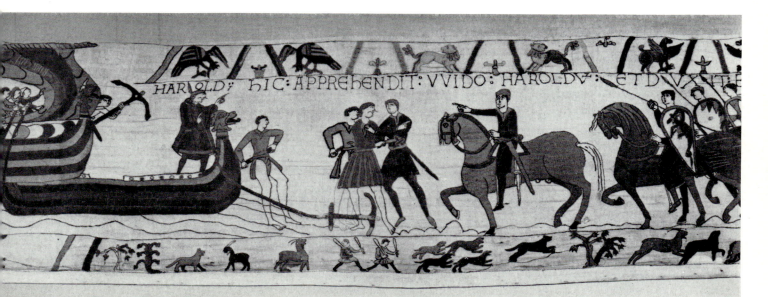

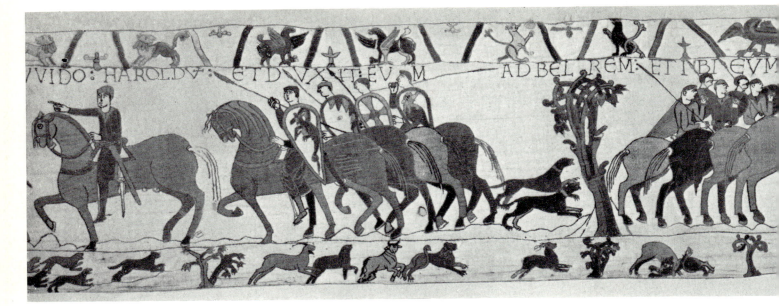

18

18, 19 The party is met and arrested on the shore at the order of Count Guy himself. Guy, on his horse, orders one of his men to seize Harold, who is seen (in Fig. 17) bare-legged after wading ashore. Harold appears to be offering some resistance, as he holds a saxe (an implement half-knife and half-dagger). Two bare-legged members of his party accompany him.

Guy is seen at the head of his mounted men. The riders are armed with swords, lances and kite-shaped shields. Guy, and his horsemen following, use stirrups and spurs: Guy's men have no moustaches, and a 'full' hair-style, a characteristic lacking in all subsequent renderings of Frenchmen until the invasion scenes.

Harold is taken by Guy to the latter's seat at Beaurain. Harold (with moustache) rides in front, bearing his hawk: he is unarmed, and without spurs. Their followers comprise two Englishmen and three Frenchmen, the latter showing for the first time the peculiar shaving of the back of the head, which is now seen consistently on the Normans. The horses have uncut manes, a characteristic of most Norman horses. The jesses (leather straps attached to the hawk's legs by which it was held) are well seen here.

Guy is now talking with Harold in the castle at Beaurain. Guy is attended by one of his men – who may be pointing at the small figure on the right – and is seated on a throne, holding a naked sword on his knee. Harold, with a companion, now holds a sheathed sword, possibly given to him by Guy as a gesture of trust. The onlookers include four Englishmen. The significance of the small figure clutching the column on the right is obscure.

19

WHERE THE MESSENGERS OF DUKE WILLIAM CAME TO GUY:
 TUROLD:

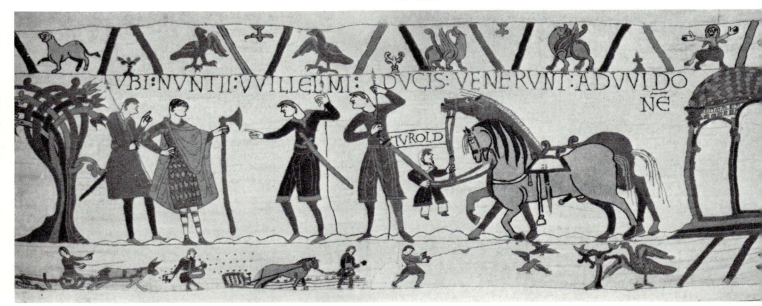

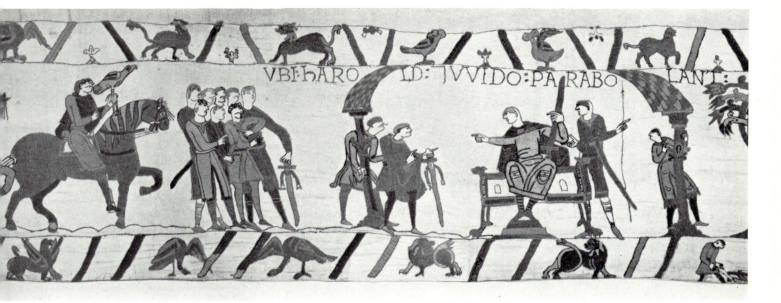

Three scenes are now shown in reversed order, presumably to improve the design. First, two messengers from William have dismounted and are demanding Harold's release from Guy. The name TUROLD refers to the taller messenger, not to the bearded and trousered dwarf who holds the magnificent horses. All sorts of speculation has been voiced about the dwarf including the bizarre notion that he was the designer of the Tapestry; but none of it is convincing (see Fig. 6).

Next we see the two messengers riding full tilt on their way to Guy.

Then there is the look-out who sights the messengers; and, finally, the scene which should be placed first, *i.e.* an escaped Englishman is in Duke William's castle at Rouen, telling him of Harold's capture, and William gestures to the two tall messengers (standing behind the Englishman) to go and rescue Harold.

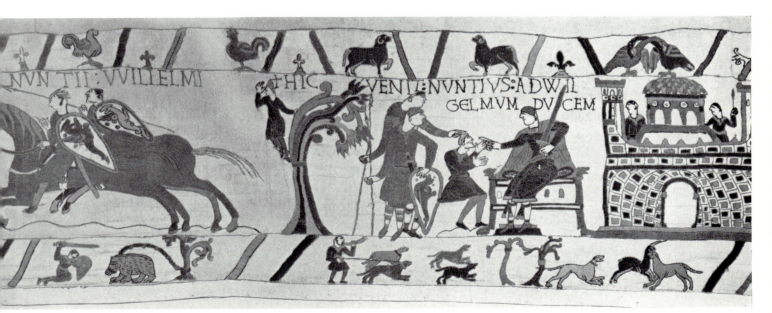

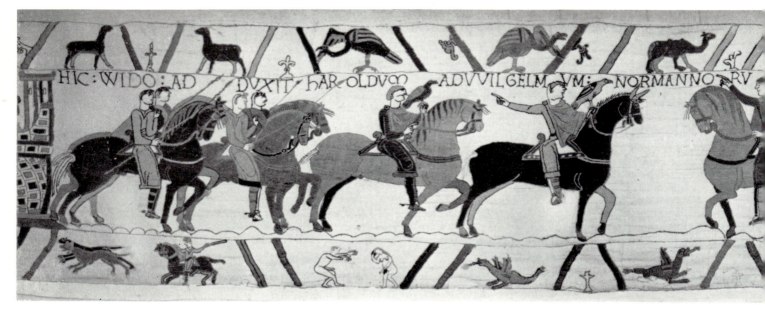

20

20, 21 Guy (in front) and Harold with their party, having ridden from Beaurain, are seen at the meeting with William, who is magnificently clad, and his armed men. Guy with his hawk, turns in his saddle and points back at Harold, also with a hawk. Harold is unarmed but now wears spurs. Guy's followers, with no Englishman included, are fully armed. Guy's mount is often referred to as a mule, but it may just as well be a mare with her ears pricked. The scene takes place at Eu, on the boundary of Ponthieu and Normandy.

William takes Harold back to Rouen, and a watchman observes their arrival. Harold, with moustache, is in front (without his hawk) on one of the Tapestry's most delightful horses. William rides behind him bearing the hawk; two of his followers (without shields) bring up the rear. Dogs appear again here with collars and leash rings.

Inside his palace at Rouen, William converses with Harold, watched by armed Normans and possibly one Englishman (the man next to Harold). The standing and gesturing figure of Harold is most expressively drawn.

The meaning of the mysterious scene inscribed 'Where a certain clerk and Ælfgyva', is now completely lost: it must have been well known to contemporaries. Ælfgyva is confronted by the tonsured and violently gesturing clerk – a clergyman – a probable reference to some scandal of the time. There have been a number of theories advanced – including the startling idea that William wanted to marry her off to Harold – but none of them is convincing (Fig. 12).

To show how William cements his friendship with Harold, the Tapestry now follows William on his expedition to defeat and capture Count Conan of Brittany. Harold is invited to go along. William

21

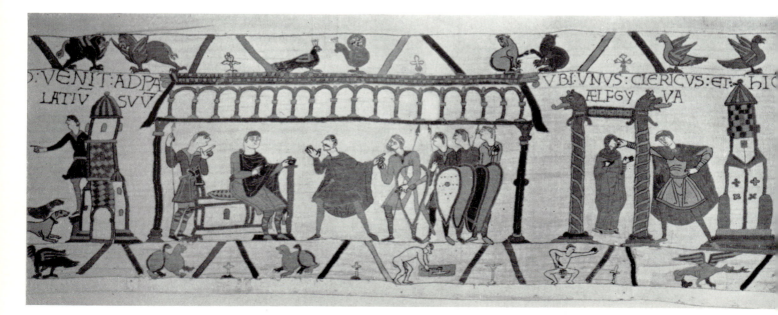

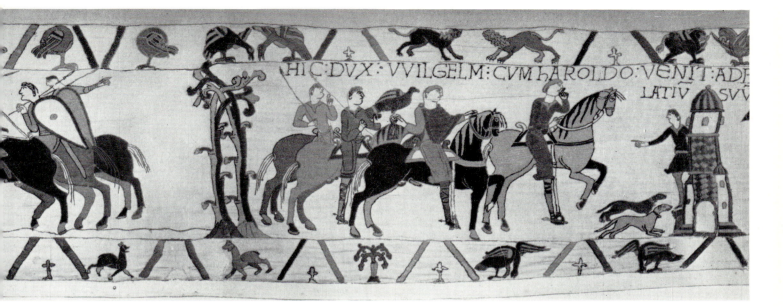

is shown (Fig. 21) wearing a quilted tunic and no armour, and carrying only a mace – a formidable weapon. He is immediately preceded by the somewhat puny figure of Harold, shown just before passing Mont Saint-Michel in the background. The troops strive to keep their weapons and shields out of the water as they start to ford the River Couesnon. Harold (Figs. 8, 22) shows his prowess by rescuing some Normans from the quicksands at the mouth of the river.

DUKE WILLIAM AND HIS ARMY CAME TO MONT SAINT MICHEL: AND HERE

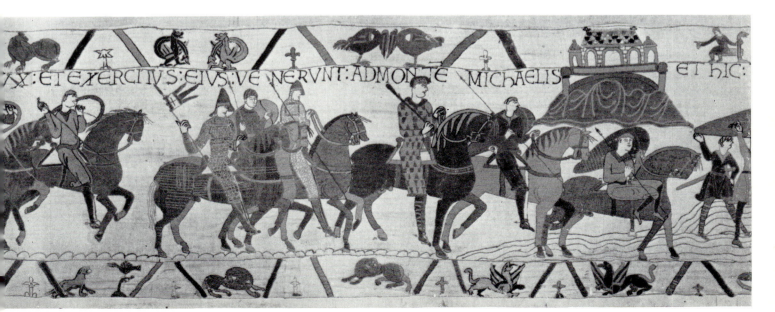

THEY CROSSED THE RIVER COUESNON: HERE DUKE HAROLD DRAGGED THEM OUT OF THE SAND: AND

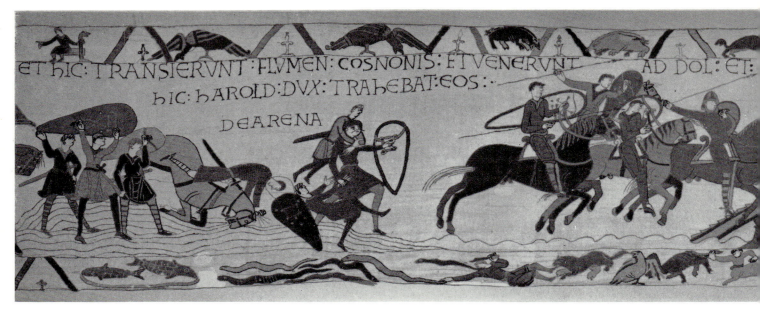

22

FIGHT AGAINST THE MEN OF DINAN:

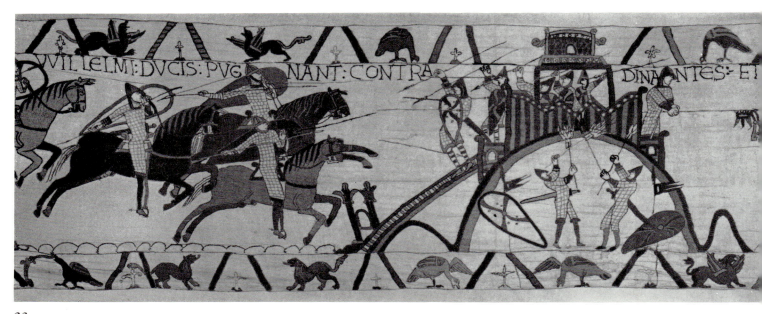

23

AND CONAN OFFERED UP THE KEYS: HERE WILLIAM GAVE ARMS TO HAROLD: HERE WIL

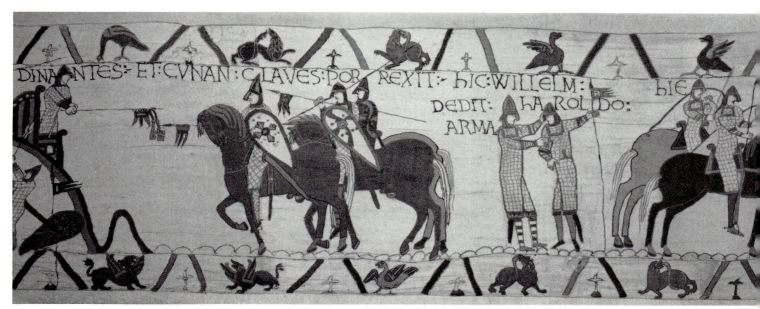

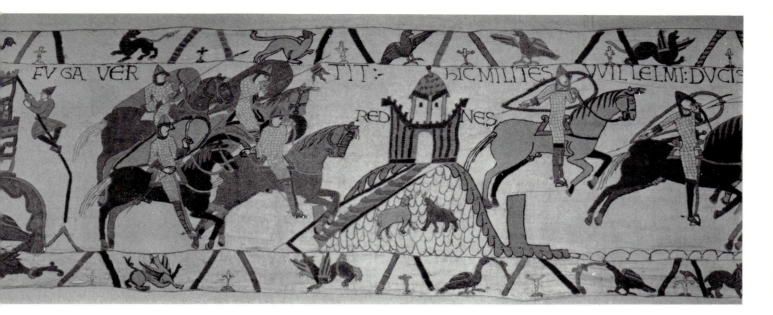

22–24 The Normans attack the town of Dol, and Conan escapes by sliding down a rope (see Fig. 7). The designer has made a mistake here, for Conan was himself laying siege to Dol, which was being held by a Breton lord in the Norman interest. He was forced to raise the siege and flee at the approach of the Normans. The 'castle' at Dol appears to have a drawbridge at the left; and, from its somewhat unsubstantial structure, was clearly a 'mound-castle', *i.e.* earthworks on a natural eminence surrounded by a wooden stockade with wooden buildings in the centre.

The Normans by-pass the city of Rennes – the capital of Brittany – which is symbolized by the hill-top 'castle' in the background. The Normans are pursuing Conan over a curiously roundabout course: Dol is near the coast; Rennes is some thirty miles farther inland; and Dinan, to which they come finally, is back just a few miles from Dol.

The Normans now attack Dinan, whither Conan has fled, and are vigorously resisted by the Bretons. The 'castle' at Dinan is shown taking part in two phases of the story. Above (left) the Bretons are resisting the attackers; while below, two dismounted Normans are setting fire to the building. Below (left) Count Conan surrenders: he places the keys of the city on the end of his lance, and transfers them to William's lance.

Then William rewards Harold for his services to the expedition by 'giving him arms' (see Fig. 9 and page 11).

William then leads his army back into Normandy, and comes to Bayeux, symbolized by the elaborate hill-top building (see Fig. 10).

The first climax of the story is now shown as Harold takes an oath of allegiance to William (see page 12).

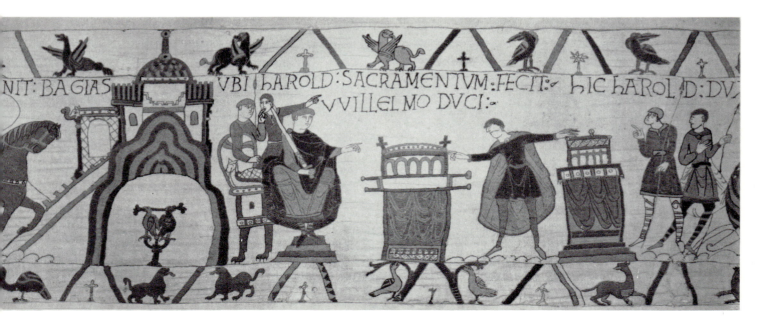

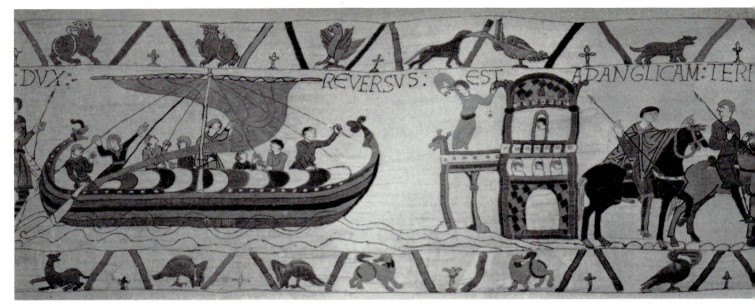

25

25, 26 Harold returns to England and is seen standing beside the mast of the ship as it approaches the English coast: the figure on the balcony, and four eager faces, gaze out to sea. The ship is again shown with overlapping shields, and everyone on board now lacks a moustache: from now on, Harold and other Englishmen – high and low – are shown both with and without moustaches.

Harold and one of his men are seen riding to London – symbolized by a tower – and then Harold visits King Edward. In the first scene Harold is the left-hand figure wearing a cloak; and in the second scene he is on the right with outstretched arms, followed by a man with an axe. The aged and bearded King sits in his palace at Westminster: he holds a staff and wears the Crown of State. His attendant carries an axe (Fig. 11).

The next scene and the one after are out of order; and it is hard to understand why the designer decided upon this reversal. We first see Westminster Abbey; next the funeral procession of Edward; and then his illness and death. The newly completed Abbey had been consecrated on 28 December 1065, an event symbolized by the hand of God emerging from the cloud above: a further sign of the building's recent completion is the craftsman fixing the weather-cock. The ailing King Edward – who had been too ill to attend the consecration of the Abbey – died on 5 January 1066. He was buried in the Abbey on the following day, and we now see the funeral procession. The King's shrouded body is borne on a bier covered with an embroidered pall: there are eight bearers and two acolytes with bells are seen below. Then come the tonsured clergy officiating at the burial, led probably by Edward's friend, Abbot Eadwine: two of the party carry open prayer-books, and those at the back are singing (Fig. 14). Next are the superposed scenes of Edward's last hours, and of his

26

TO THE CHURCH OF HERE KING EDWARD IN BED HARANGUES HIS FAITHFUL FRII
ST. PETER THE APOSTLE: AND HERE IS HE I

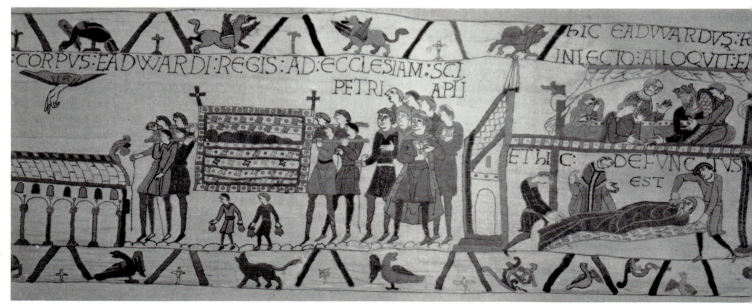

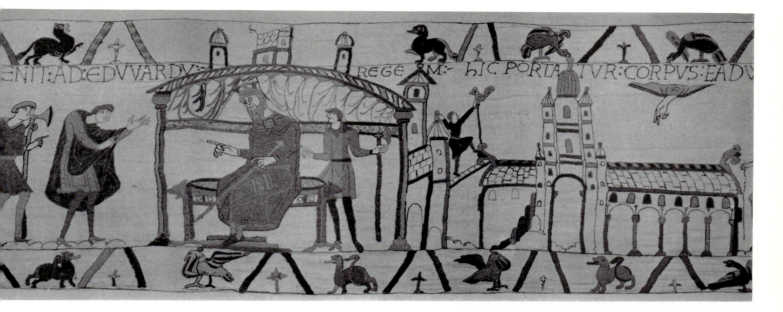

death: the King, supported on his death-bed by Robert the Staller (?) speaks to Harold: on the far side of the bed are seen Queen Edith (who was Harold's sister) and an ecclesiastic (see below). In the scene beneath, the dead King is prepared for burial by two attendants, with the ecclesiastic looking on (Fig. 13): it may be that the designer intended to depict Archbishop Stigand in both scenes, but it is curious to see that, when the Archbishop is introduced by name, he is shown clean-shaven, whereas the man here is bearded.

Next we see two leading nobles of the Witan offering the crown to Harold: one holds out the crown to Harold, and the other holds out the official axe – a symbol of authority. Harold, one hand on hip and the other holding an axe, accepts the offer (Fig. 15).

Then comes, not the Coronation scene, but Harold – already crowned with the Crown of State – being acclaimed by nobles and people alike. Harold was crowned in Westminster Abbey as Harold II on 6 January, probably by Ealdred, Archbishop of York, although Stigand is shown here. Harold is enthroned in the Abbey, holding the orb and sceptre. On the left a noble holds aloft the Sword of State: on the right Stigand raises his hands in a ceremonial gesture, a maniple over his left hand. On the right, the people acclaim the King. It will be noticed that Harold has here a prominent moustache, which has disappeared when he is seen next.

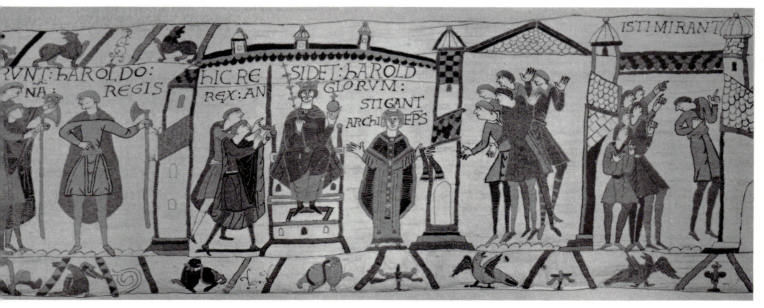

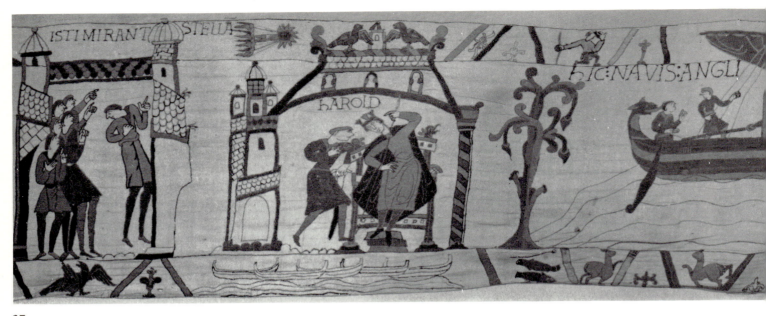

27

27, 28 Halley's Comet (see page 12) appears and terrifies both the people and the King. On the left the crowd points upward to the comet (in the border).

Harold is then told of the bad omen; and beneath (in the lower border) are the ghostly invasion ships which he sees in his imagination as a punishment for accepting the throne after his oath to support William's claim. This is another occasion when the main story invades the borders, as it does frequently in the later portions.

A ship carries the news of Harold's crowning to France. The ship is of an unusual type for the Tapestry, having no oar-ports; it flies a small pennon (or pennoncel) at the mast-head. The man in the bow sounds the depth while a bare-legged member of the party wades ashore with the anchor: the latter man is of particular interest as clearly having the Norman-style shaven head.

Having been told of Harold's coronation, William decides to invade England and gives orders for the building of the invasion fleet. Enthroned, with arms crooked, he is turning to his tonsured half-brother, Bishop Odo of Bayeux, who gestures towards the ship-building scenes beyond. The man on the left is either the messenger bringing the news of Harold (although William was said to have received this news while hunting) or, less probably, William Fitz-Osbern, William's second cousin, who was one of his most important nobles, and possibly second-in-command of the invasion of England. The man on the right is a craftsman – he carries an adze – to whom the orders for ship-building are given. The scene probably takes place in the palace at Rouen. A small but particularly interesting point here is the abandonment, for William and almost all the other Normans who follow in the Tapestry, of the shaved-head hair-style; there is no known explanation of this, and in

28

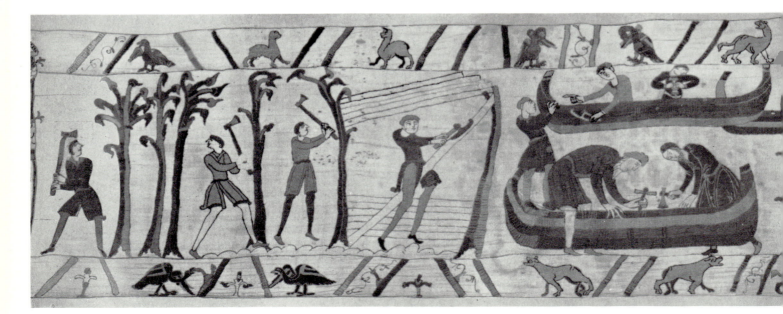

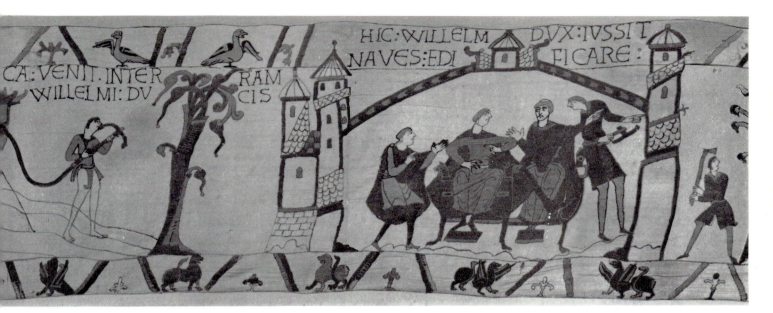

the rest of the Tapestry only a few men – nobles or others – are seen shaved. Bishop Odo appears now for the first time, and hereafter takes a prominent part in the Tapestry.

The woodmen go to work felling trees; a craftsman sits astride a beam and shapes it with an adze, while piles of beams or planks lie above and behind him; and shipwrights build the vessels. The ships are shown even shorter than usual, for purposes of artistic composition. In the upper ship the first man holds an adze; the second what appears to be a drill. The adze was later to be adapted as a military weapon. The two bearded men in the boat below handle two forms of small axe (Fig. 40). The completed ships are dragged down to the sea by means of ropes and a pulley arrangement attached to a post. The bare legs of the men and the wavy lines signifying water suggest that the posts were driven in some way offshore to provide the maximum assistance in launching the vessels. The decorative tree forms an admirable dividing line between the ships under construction and those completed, with one vessel overlapping both scenes. As the invasion fleet assembled off the mouth of the River Dives, it is probable that some area near the village of Dives was a traditional boat-building centre in the eleventh century. Dives-sur-Mer is fourteen miles north-east of Caen.

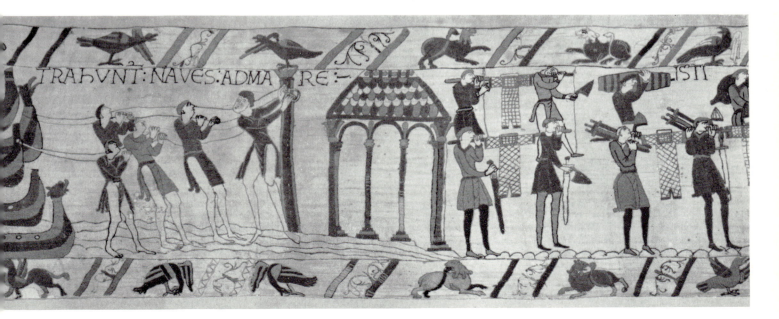

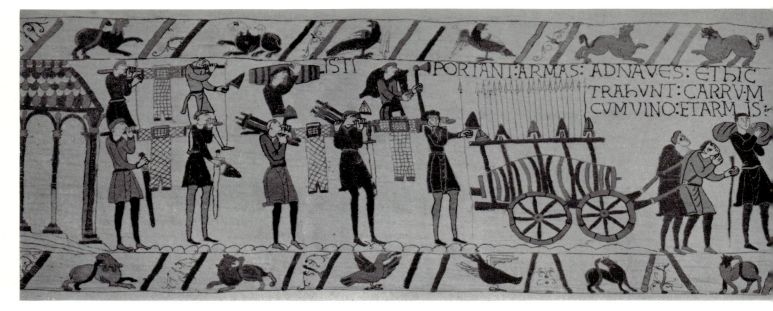

29

29–32 We now see supplies, arms and armour being taken down to the ships. The men in the top row carry a hauberk, lances, a helmet, a small barrel of wine, a skin of wine and an axe: below, the others carry hauberks, swords, helmets and lances (see page 7). It will be noticed that the invariable way of carrying the helmet was by grasping the nasal. Next, a huge barrel of wine on a cart is drawn by two men, which also bears lances and helmets.

In one of the few ill-executed scenes, William now leads his army down to the beaches.

Then the invasion fleet sets sail (see page 12). The ships are shown overlapping to give a massed effect, and the square sails shown blown out by the wind in the convention adopted by the designer.

The fleet lands at Pevensey (see Fig. 31 overleaf). Seamen unstep the mast of a ship and the horses are jumped over the low gunwales. Then horsemen are soon in the saddle, and they gallop off unopposed by any English army, and make for Hastings.

The Normans are then seen foraging in the countryside. On the left two men are seen with a sheep, and behind them an ox lies on the ground; next comes the controversial figure (who one early historian thought was about to lasso the ox!) holding a circular object, which has now been identified as a stone or boulder: then there is a man carrying a pig over his shoulder. One Norman knight is singled out by name in the inscription as Wadard, who thus must have been a figure of special note to those for whom the Tapestry was designed: a Wadard appears in Domesday Book as holding lands in England under Bishop Odo. Wadard rides towards a man with an axe who leads an attractive pony, whose skirt-like saddle attachments suggest that he is equipped to carry bales or

30
CROSSED THE SEA

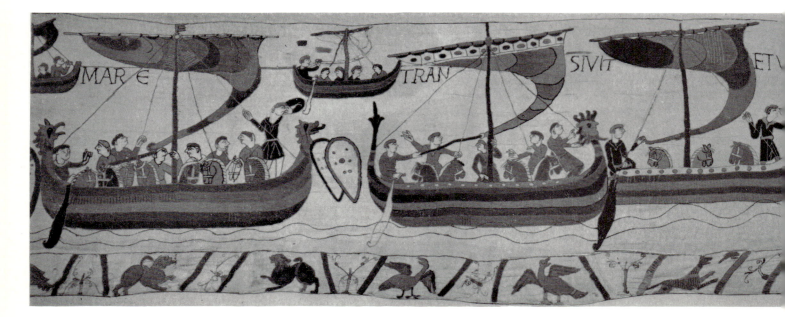

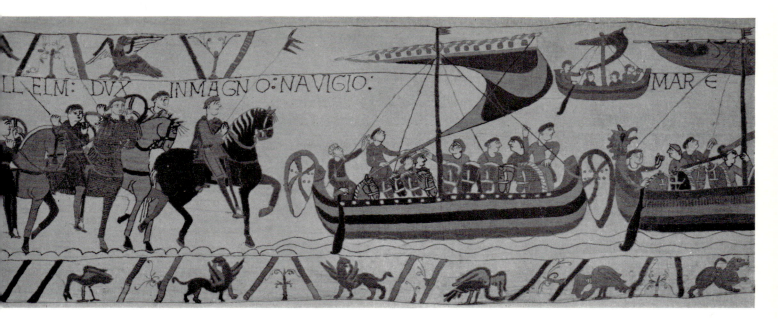

burdens slung on either side. The small buildings in the background seem to indicate humble dwellings, two of them with plank or slate roofs, and plank sides.

In Fig. 32 (overleaf) the army commissariat prepares food for the Norman 'staff'. On the left two men are boiling meat in a large hanging cooking-pot, with a rack of spitted fowls above: next is a bearded baker who wields a pair of tongs to take bread or cakes off a stove, and place them on a trencher. Both the cooking and the meal seem to be taking place in the open. Kitchen servants are then seen handing spits of cooked meat to the waiters inside. The indoor servants receive the food and arrange it on a table made of shields laid on trestles, and one of them blows the 'dinner is served' call on a horn (Fig. 44; see page 9).

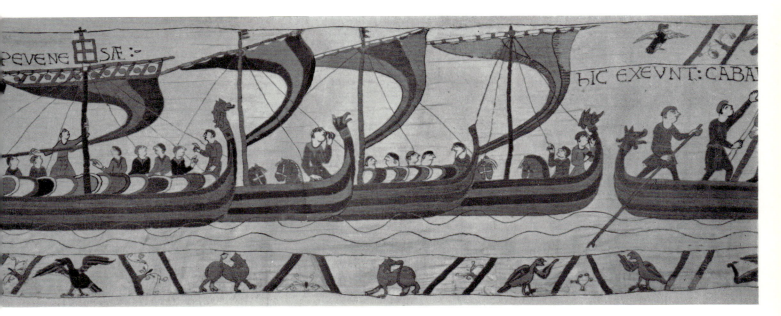

HERE ARE THE HORSES
LEAVING THE BOATS:

AND HERE THE SOLDIERS HAVE HASTENED TO HASTIN

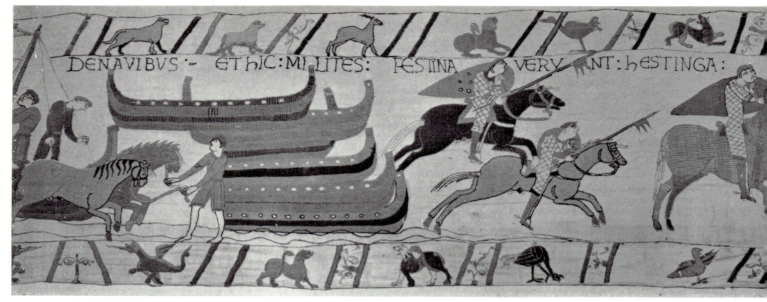

31

HERE IS THE MEAT
BEING COOKED,

AND HERE THE SERVANTS
HAVE SERVED IT UP:

HERE THEY MADE A BANQU

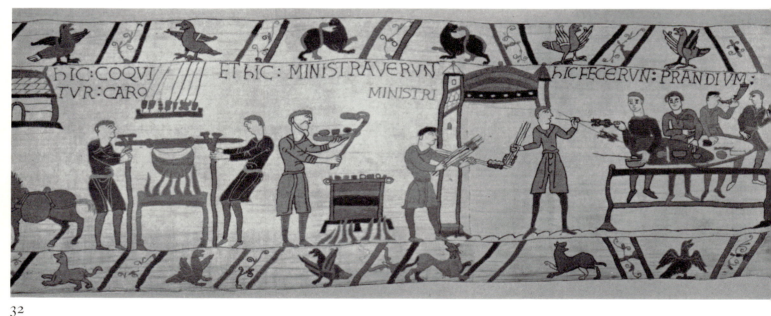

32

AND HERE THE BISHOP BLESSES
THE FOOD AND DRINK:

BISHOP ODO,
WILLIAM, ROBERT:

THIS MAN HAS COMMANDED THAT A CAST

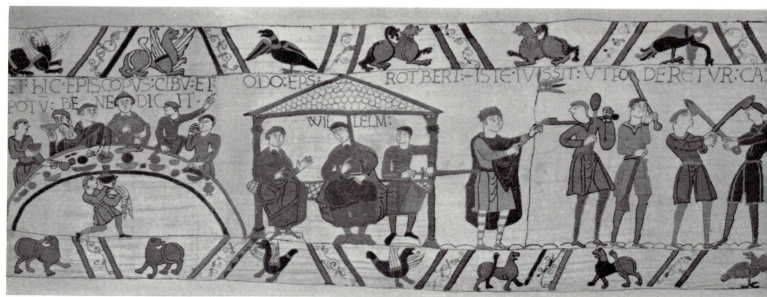

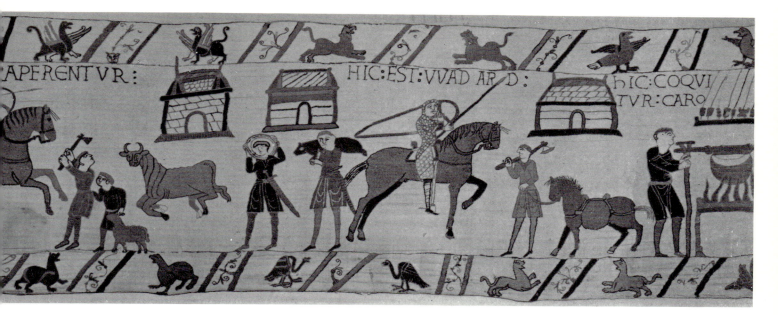

33 William and his nobles now sit down to feast, and Bishop Odo (in the centre with raised hands) says grace; William sits between Odo and the bearded man. On the table are spread out the food, pots and implements, with fish clearly seen. In front is a servant carrying a bowl for washing their hands and a large napkin. There has clearly been a bad blunder by the designer (or embroiderer) in the two arms immediately above the kneeling servant.

In a formalized building, with a tiled roof, are seen William and his two half-brothers in conference: Bishop Odo sits on the left and Robert of Mortain on the right; William holds an upright sword.

Next is an officer holding his spear (with gonfanon attached), who gives orders to build fortifications outside Hastings: the workmen carry a pick, metal-shod spades and both oval and splayed shovels; the spades have only one foot-tread. The two men on the right seem to be fighting, although the combat looks rather decorous. William had decided to fortify Hastings, centred on a stoutly built 'mound-castle' in the form of a stockade and earthworks. An officer supervises the labourers. These men are probably Englishmen.

On the right, the seated William receives news of Harold's movements from a knight who gestures before him; this knight may be Robert the Staller. For the first time we see the Papal Banner, held by the Duke (see page 13).

There is no known explanation of this burning of a house, with a rich woman (shown by her dress) and her son being driven away: it must have been a well-known event at the time.

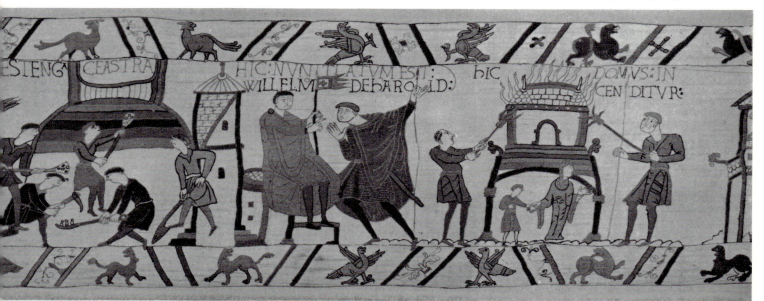

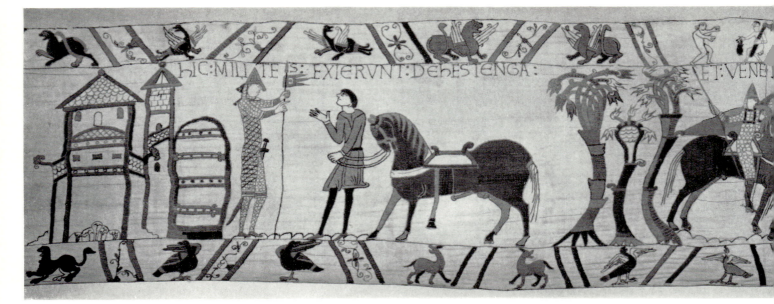

34

34, 35 William, in full battle armour (with 'rank-tabs'), is about to mount his horse. His groom leads up the superbly drawn Spanish charger which King Alphonso had presented to William. Wace (in his *Roman de Rou*) says that the man leading the horse is Walter Giffard, Lord of Longueville, who had brought the stallion back from Spain: but, like so much of Wace, it is fanciful. This man does not look like a noble. William of Poitiers relates that William's hauberk was at first put on him back to front; but that William said, to his superstitiously fearful servants, it was a good omen and symbolized his turning from a Duke into a King.

The time is now the early morning of Saturday, 14 October 1066. The Norman army is leaving Hastings to do battle with Harold. The designer is seen here at his best, creating an exciting crescendo of horse movement as the mounted mass of knights on the left, their lances falling from vertical to oblique, grows into the line of galloping men on the right; William (at the head) has here exchanged his lance for a mace, which he will always be seen carrying hereafter. In the massed group of horsemen it will be seen that the designer shows ten men and eight horses, the latter with only twenty-five legs between them: the omission of some of the legs – always the back legs – helps to speed up the movement of the composition. All the Knights are fully armed, armoured and accoutred, and only two of the leaders bear flags on their lances, probably because the gonfanon was a special battle flag, and was only carried by the leaders. One has a normal-shaped gonfanon, the other a curious form of half-moon pennon with small tails around the edge: this flag has sometimes been mistaken for the Papal Gonfanon (see page 13).

35
HERE DUKE WILLIAM ASKS VITAL WHETHER HE HAS SEEN HAROLD'S ARMY:

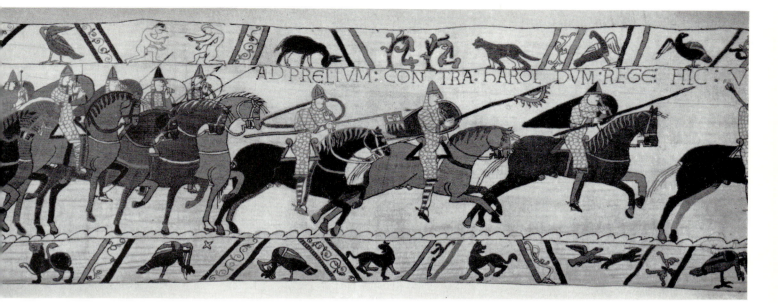

William is in the lead of this last scene; and then is immediately shown again – a clumsy design feature – asking Vital for news of Harold. On their right are seen the Norman scouts, probably on what is today Telham Hill, a mile from the slope on which Harold's army is drawn up.

Now, after the decorative trees denoting a change of scene, we see Harold's scouts, on foot, who are out watching for the Normans. One looks out, shielding his eyes; the other reports to Harold. This is the first time the English army appears in the Tapestry: the men are armed and armoured like the Normans, except for their axes, which will be seen later. Harold, heavily moustached, is seen mounted and pointing ahead: he is wearing his sword outside his hauberk, and carrying a lance without a gonfanon.

THIS MAN GIVES NEWS TO KING HAROLD ABOUT DUKE WILLIAM'S ARMY:

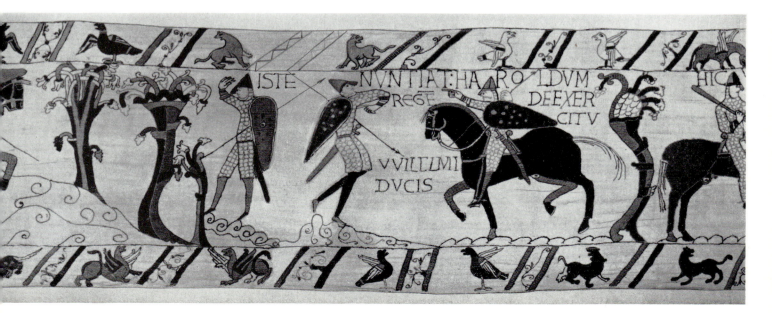

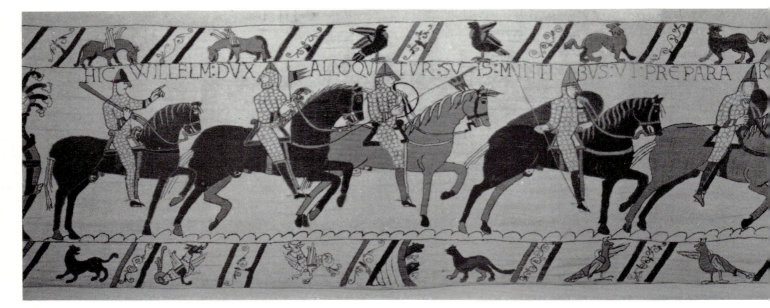

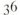36

36, 37 The battle is about to commence, and William (on the left and carrying a club or mace) exhorts his soldiers. From now on, the Tapestry displays, with great vigour and beauty, the Battle of Hastings. But it is, with a few exceptions, a highly stylized battle and bears little relation to the actual course of events (see page 14). We see William and two of his knights – one of them without a shield – going into action. The exhortation and the beginning of the action are necessarily merged. William will only appear once more in the Tapestry (in Fig. 39). The Norman cavalry get going. In this vigorously galloping line, the knights carry their lances in a variety of attitudes, couched, upright, and ready to be hurled like javelins. Shown clearly are the two chief poses which the designer adopts when the horses are galloping: one with the forelegs stretched out in front in a graceful bow, the other with the legs bent in an almost jumping gait. The arched bodies of the men with raised lances are very impressive, and the pose is well coupled with the bent legs of the horses. In between the horsemen are the Norman archers: of the four men shown, one is in full armour, with short-length hauberk and helmet; two wear soft conical caps; and one is bare-headed: three carry their quivers hanging from a waist-belt, and one from a shoulder strap; the armoured figure has removed all his arrows from the quiver and holds them clustered in his bow hand, presumably for rapid loading (Fig. 45). The Normans used the comparatively weak and so-called Danish short bow (see page 7).

A great panorama of the battle starts to be spread out here, with the cavalry attack being delivered – for decorative purposes – from two sides, whereas the English were lined up on a hillside, with the Normans attacking from the front. The formidable English shield-wall is well shown in the centre, and the Norman cavalry attacking from the left are particularly fine and vigorous. Lances and spears

37
FOR THE BATTLE AGAINST THE ENGLISH ARMY:

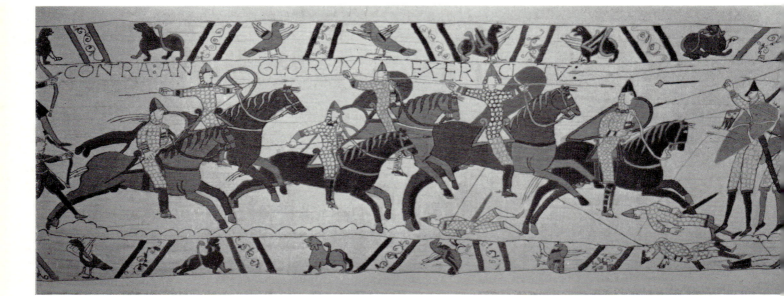

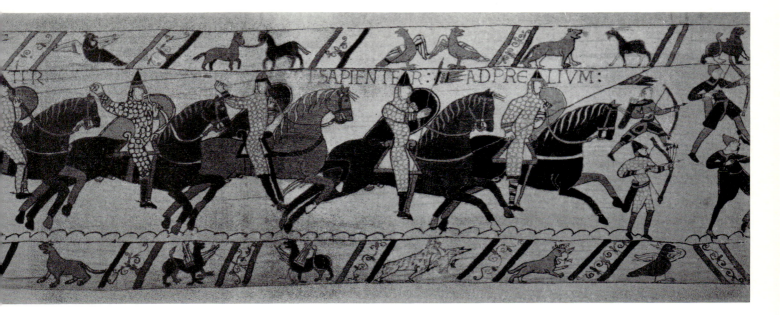

fly through the air, launched by both armies, and a club is flung for good measure by the English; a solitary English archer is also in action. In these scenes only one lance with a gonfanon is being used for attack (by the foremost horseman); and one Norman knight, having flung his lance, is riding in with a drawn sword. The javelin function of the spear was an important consideration for an army lacking archers, and this is shown by two of the Englishmen holding sheaves of spears. The great two-handed Danish axe appears here for the first time: one is seen being wielded by the Englishman on the far right, and another – inactive – on the left (Fig. 46). Two English gonfanons, one of them four-tailed and borne on a staff, are seen here. The lower border is again invaded by the main story, and now becomes the repository for slaughtered soldiers, who lie there shot, speared and beheaded, preceded by two up-ended birds, as if the designer had intended them to echo the general carnage (Figs. 47–50).

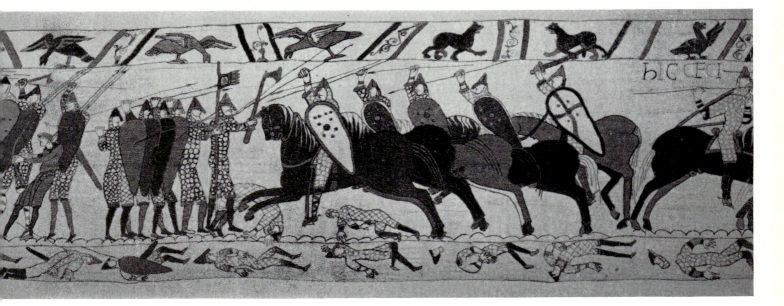

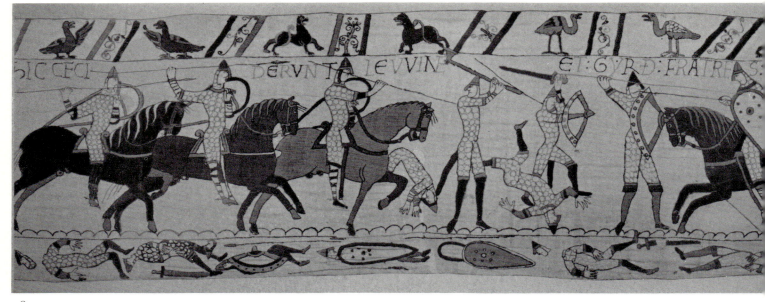

38

38, 39 Here is another panorama of combat, this time rather weakly conceived when compared with the rest of the battle scenes: the particular incident shown is the killing of Harold's brothers Leofwine and Gyrth, one jack-knifed and the other cart-wheeling in death. For the first time round shields appear in the hands of the English, as they set about them with sword and axe. The lower border continues to be littered with the dead and their weapons: incidentally, it must have been a herculean blow that could so easily behead a man wearing a chain-mail coif. Beneath the horse on the right is the oddest of all flags seen in the Tapestry, a triangular pennon with short tufted tails on its lower side.

We now come to one of the most brilliant pieces of draughtsmanship in the Tapestry – the crashing Norman horses. We see a dismounted Norman attacking an Englishman and 'hacking' the head off his axe; then an English axe-man cleaving the head of a horse as its rider aims a blow; and then the tumbling, rearing and pitching horses, flinging their riders to the ground in a turmoil of movement, as the Normans attack the defenders on the hillock. This incident may well be the annihilation of the cut-off English who pursued the Bretons in phase two of the battle (see page 14). It is curious that none of the English is here seen in a hauberk, and that one is bearded. Very heavy moustaches occur on no less than four men in this group, as if some special significance attached to them. Dead men, and now dead horses too, fill the border: the crumpled man on the right in the border of Fig. 38 is curiously echoed by the bowed form of the plant above – the only plant to be seen on the entire battlefield.

39

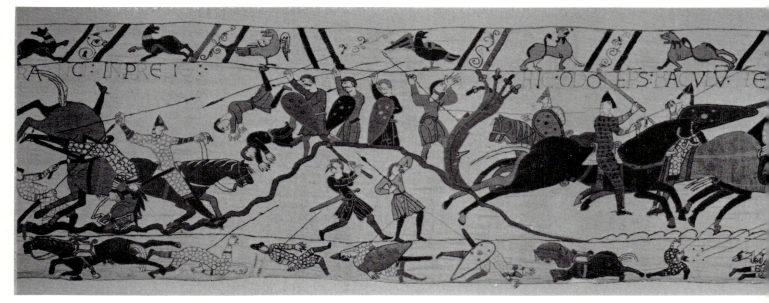

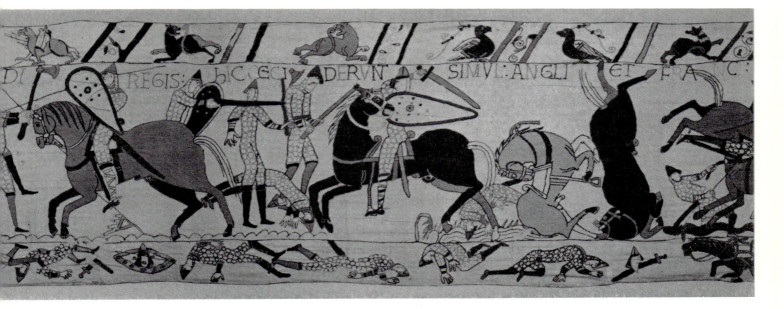

Now comes an incident that actually took place early in the battle: after the rout of the Bretons, a rumour spread that William had been killed; whereupon the Duke thrust up his helmet to show his face. The inscription states, 'Here Bishop Odo, holding a mace, cheers on the young men' and then, a few inches farther on, 'Here is Duke William'. The 'young men' referred to are probably the youths who were not yet knights, and who may well have been some of those affected by the panic. Odo, with his mace, is seen to the right of the hillock wearing a quilted (?) tunic over his hauberk, the coif and sleeves of which can be clearly seen emerging. Ecclesiastics were not permitted to shed blood with the sword in action, but were allowed to fight with the equally lethal club or mace! Next come the youths – one of whom is horseless – and then William who, standing in his saddle and looking back at the riders, points to his own face; he has pushed back his helmet so that the nasal juts out above; with his left hand he clutches his mace. Just ahead of the Duke rides Eustace of Boulogne, pointing to his master for all to see. But more important, he carries aloft the Papal Gonfanon Banner, which waves bravely in the upper border, its three long tails given decoratively conventional knot-like twists (see page 13). The charge then continues.

Meanwhile the lower border has exchanged the dead for the living, and we now see a continuous row of archers there: most have quivers. This array of bowmen may have some vague relation to the combined forces attack which won the day.

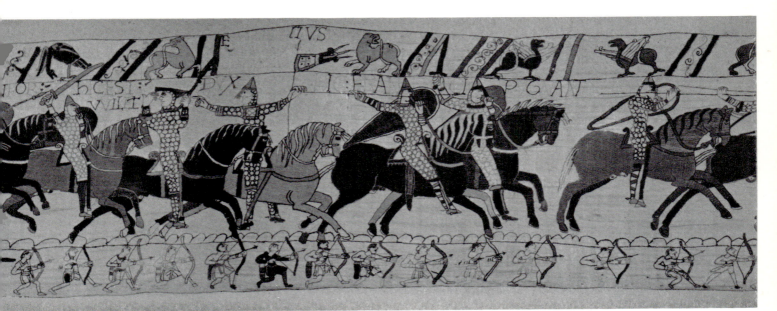

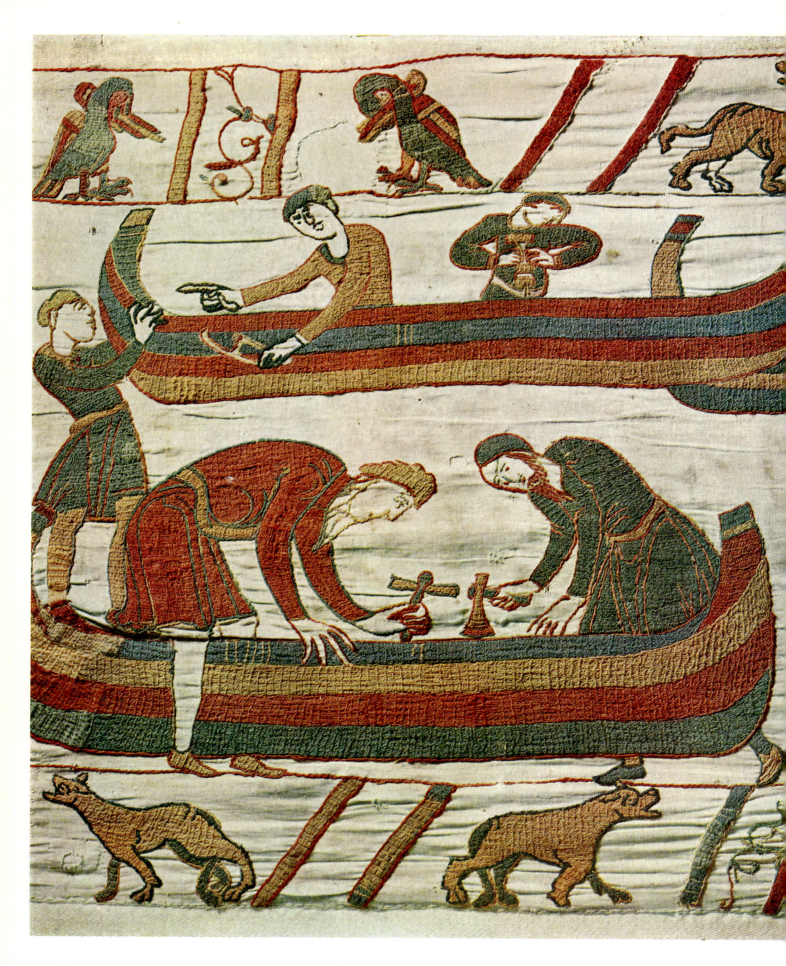

40 Shipwrights at work on the Norman invasion fleet. Exigencies of space and composition precluded any attempt to render these Viking-type ships in their true length and elegance, and what we see here are mere symbols of ships. It is still a mystery how William managed to bring together the enormous amount of labour, skill and materials necessary to build his large invasion fleet. The shipwright on the left, in the top boat, holds an adze in his left hand; and his colleague on the right operates what is almost certainly a drill, one of the earliest medieval representations. The two bearded men below are working with two kinds of small axe.

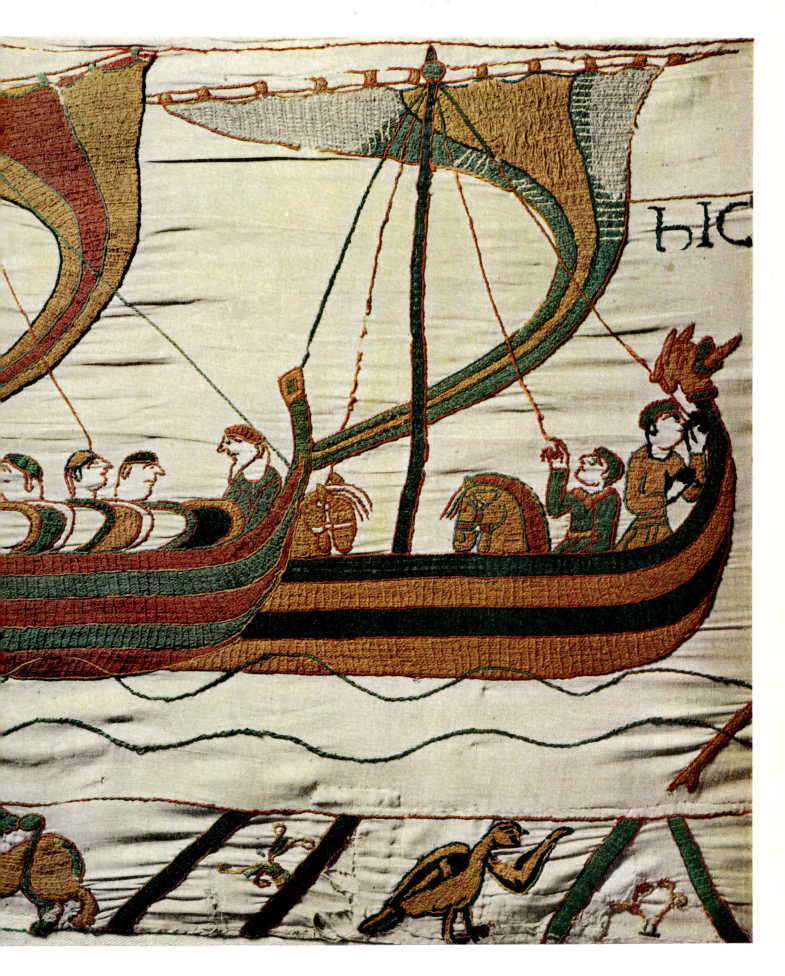

The invasion ships at sea. These two overlapping ships with their respective cargoes, are almost
cally delightful by the visual standards of today. The designer has adopted the formal idiom
wed-out sails to symbolize a square sail caught by the wind, and the treatment is most effective.
e left-hand ship we see the heads of the invaders above the line of shields along the gunwale,
e they would never be during a voyage – the designer was clearly a landsman – and the right-
vessel displays two delightful horses looking exactly like the knights of chess. Note the fine
-post carving of an animal's head on the right-hand ship.

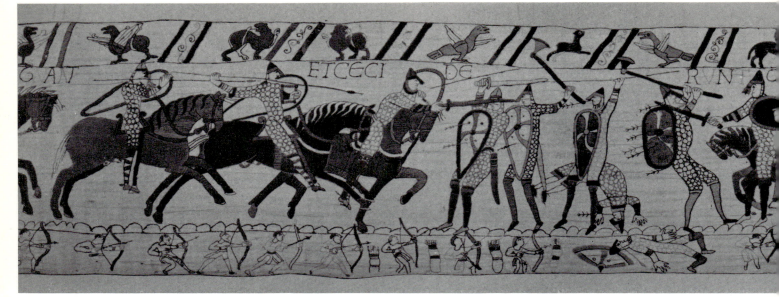

42

43

AND THE ENGLISH HAVE TURNED IN FLIGHT

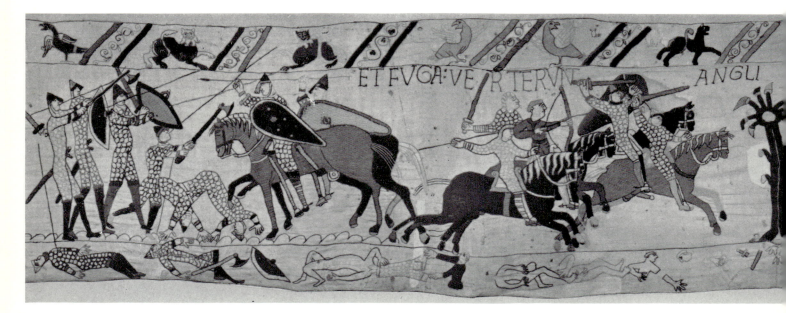

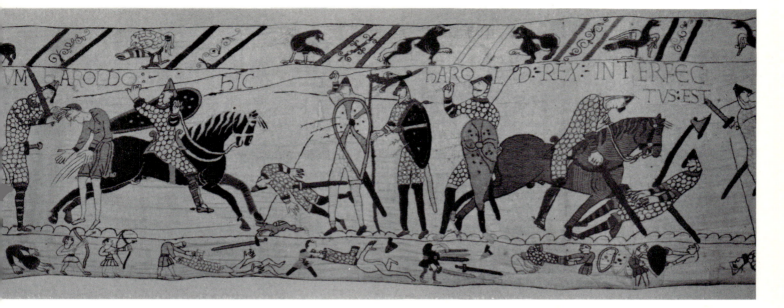

42, 43 Here is more attack and defence. A Norman brings down his sword on an Englishman's face; an Englishman turns turtle with an arrow in his head; another with axe raised, is felled by a Norman horseman who has jerked himself out of his saddle and right down into his horse's neck! In the border the archers have suddenly been provided with giant quivers that stand between them, while an Englishman lies amongst them, shot in the eye.

Next is the mysterious figure of an unarmed Englishman who is grasped by the hair and is about to be killed by a Norman; then the armed figure grasping an arrow apparently in his face, traditionally said to be Harold, but who is not Harold (see Fig. 54 and page 15). The main focus of this section is the English headquarters group. With this English command-centre now over-run, the battle nears its end: in the border this is symbolized by the dead being stripped of their armour, and weapons being gathered by the victorious Normans.

Now we come to the climax of the story (Fig. 54). Harold is hacked down and killed by a Norman knight (see page 15).

With Harold dead, the English resistance is at an end. The central scene of this section symbolizes the last stand of the defenders, who fight back with swords and axes. The lower border shows the collection of shields on the battlefield, two dead Englishmen, and a corpse being stripped.

The battle is now over, and the Normans are in full pursuit of the survivors. Two knights are in the lead – one of them bestraddles both horses – followed by a mixed trio, one a mounted archer. Beyond the scene-dividing tree, the ragged end of the Tapestry shows superposed scenes: above are English survivors flying from their pursuers, having presumably thrown off their armour, with three of them carrying maces (?) and one clutching an arrow in his eye: below there is a most curious group of two horsemen, armed only with whips, confronted by a man who seems to be wrestling with two serpents or twisting plant stems, the significance or symbolism of which is now lost to us. In the lower border are naked corpses and – beyond a dividing tree which echoes the large tree above – what appears to be a nude man, possibly wounded, holding a plant. The figures in this part have been much restored in the nineteenth century.

There would not appear to have been much more of the Tapestry length, and its ending has never been recorded. But, despite some dissident opinion, many of us would feel confident in assuming that there must have been a 'bordered' ending in harmony with the 'bordered' beginning. As Edward the Confessor is seen at the start of the story, it would seem inevitable that an enthroned William should sit at the end. If the Conqueror did not appear here, it leaves the last appearance of so important a character in the thick of the battle, which would scarcely commend itself to any patron. Certainly no designer would think of completing such an elaborate work without a fitting and harmonious end-piece; and so the present writer, at any rate, feels that it must have been King William the First enthroned at Westminster.

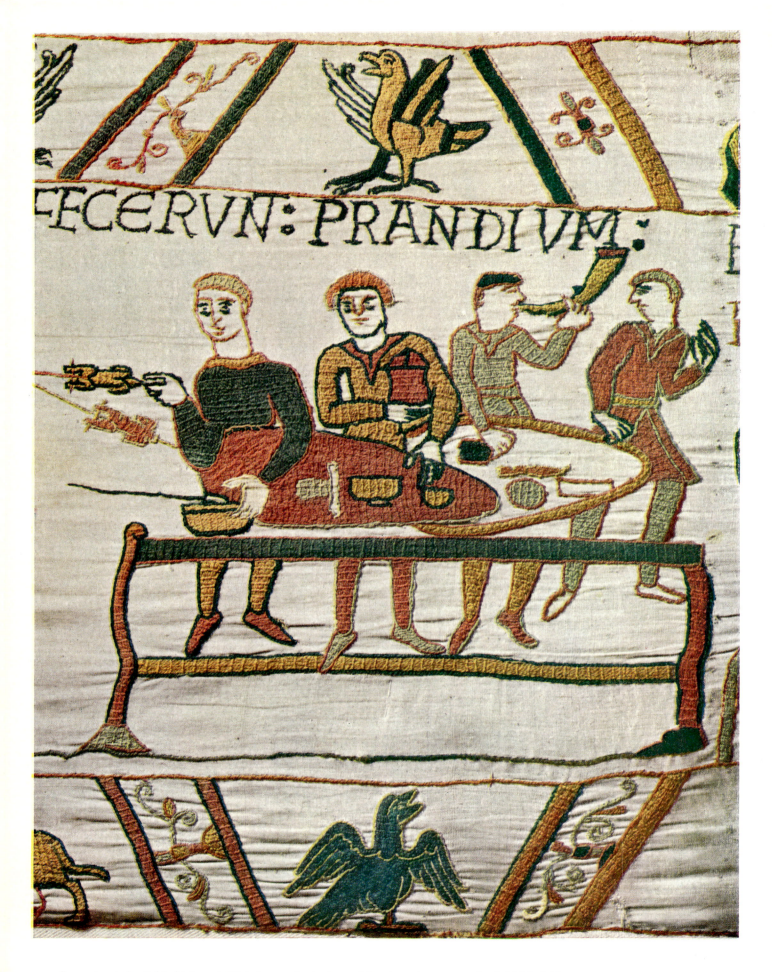

44 Servants at the field sideboard. This improvised piece of furniture is composed of shields laid on trestles, on which the food is made ready to be handed to the seated company. One servant is summoning the diners to the meal by blowing a horn, while his companions on the left take delivery from the cooks. Two animals on spits are being passed across, and a third is already in the big bowl on the left. Other bowls and implements are seen set out on the shields awaiting removal. A lovely multi-coloured bird is shown in the upper margin, and a less happy specimen appears in the lower.

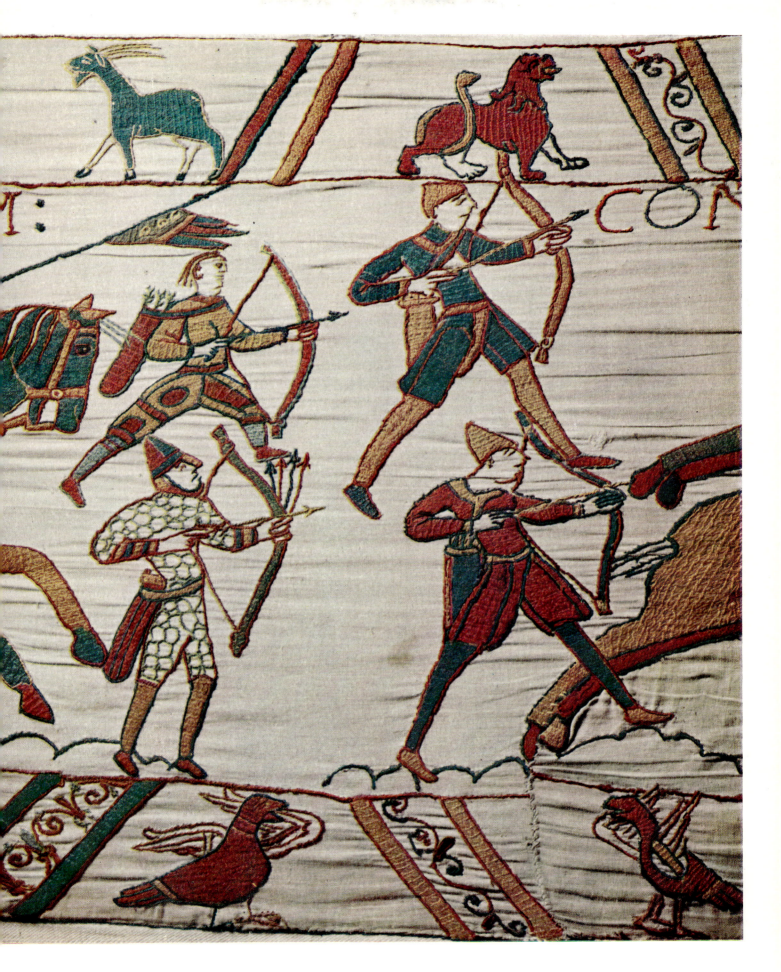

detachment of Norman bowmen. A splendid scene of tension and drama is conveyed in these
tle figures. Three of the men are in civilian dress, wearing some sort of trousered tunic to
maximum freedom of movement; each has a quiver of arrows slung from a strap round his
Two of these men wear 'Phrygian bonnets', and one – a raffish looking character – is bare-
. The fourth man wears full-dress 'regimentals' – hauberk and conical – and it will be noticed
has removed all his arrows from the quiver and holds them in his left hand, presumably for
oading.

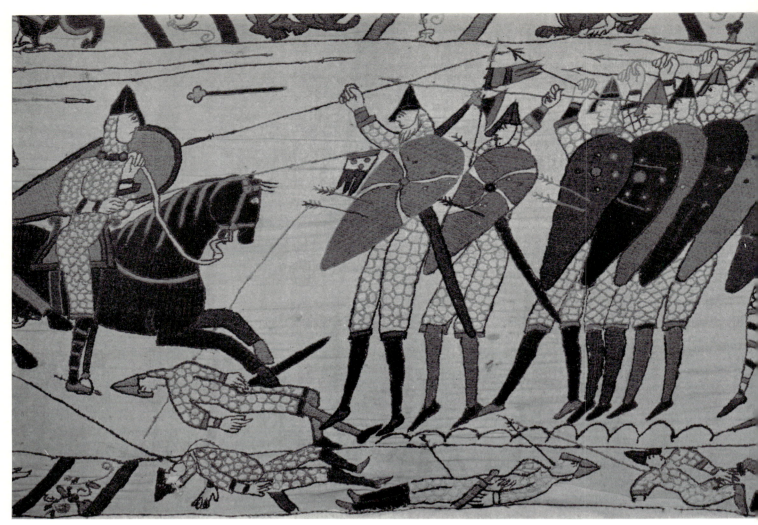

46 Here is one of the finest of the battle scenes in the Tapestry, with the Norman cavalry rushing in from both sides: this is a design convention as the English troops were in a line facing the Normans as they stormed the hill. Dead soldiers are lying in the border. The horsemen are throwing their lances, javelin-fashion, at the English troops ensconced on the hillside, and presenting the formidable

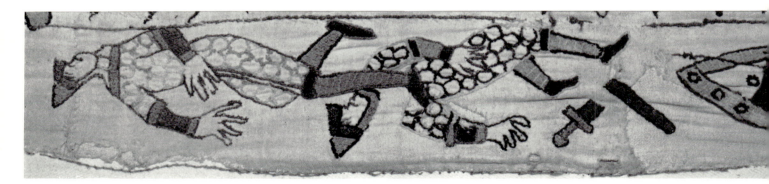

47, 48 The violent action of the battle spills over into the border. Here a dead man lies, his sword broken. Below are a dead horse and his rider, the man pierced by a lance, his helmet knocked off and his head covered only by the coif.

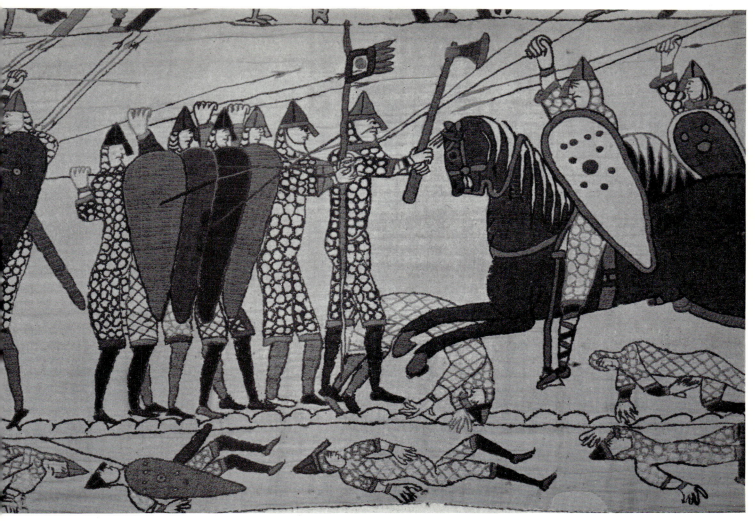

-wall which was a major feature of the English defence, with the shields interlocked to give
protection. The English are replying in like fashion to the Normans, with lance-throwing;
addition we see a huge metal-headed mace hurtling through the air towards the oncoming
. In the centre is a lone English archer.

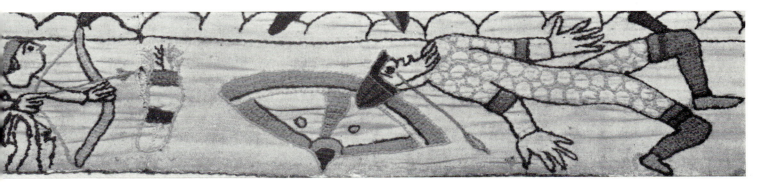

Above, an archer crouches on the left; in front of him with his shield, a dead warrior lies,
the eye. Below, a corpse is being stripped of its hauberk, which is being pulled over the
though it were a stiff shirt. (see page 7).

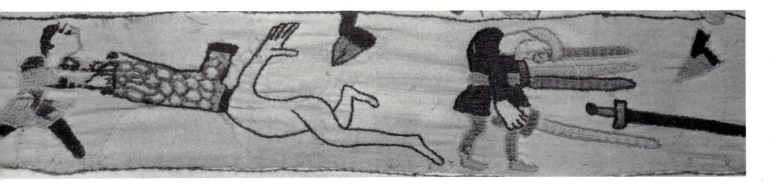

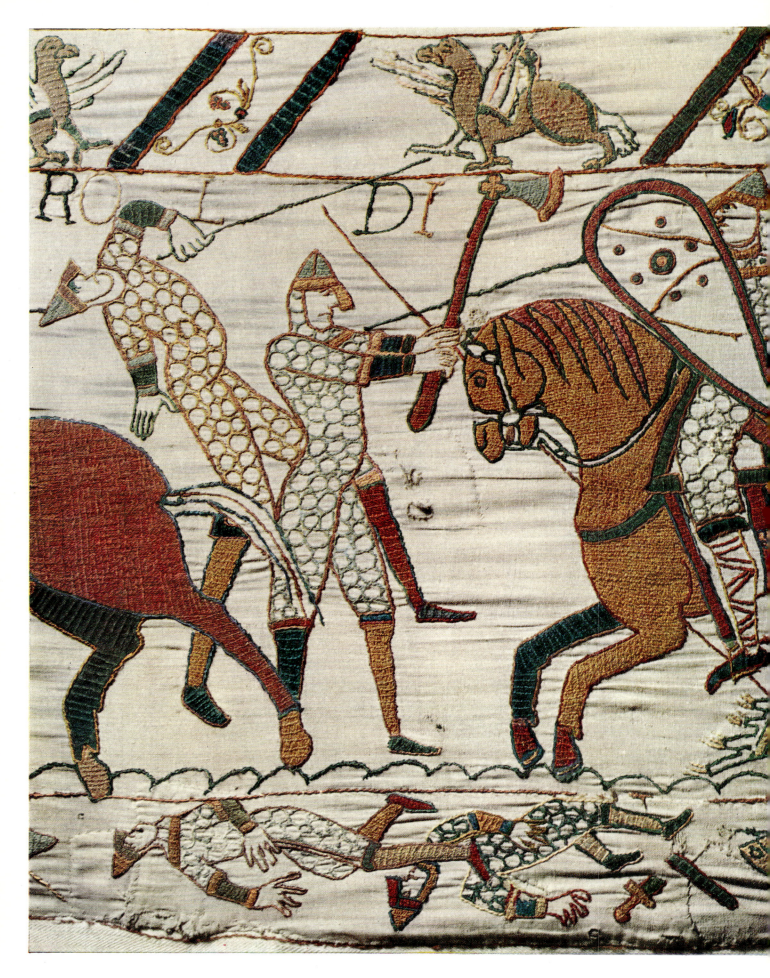

51 Stroke and counter-stroke during the Battle of Hastings. Two English infantry soldiers are shown between the attacking Norman horsemen; the man on the left has been pierced by a lance and is falling; but his companion is aiming his formidable axe at the oncoming Norman – on a veritable rocking horse – who is trying to spear him. This illustration provides excellent close-ups of the conical helmets and hauberks, a war-axe, a shield, and other details of the accoutrements and equipment. In the lower border lie two dead soldiers, one with his broken sword and shield nearby.

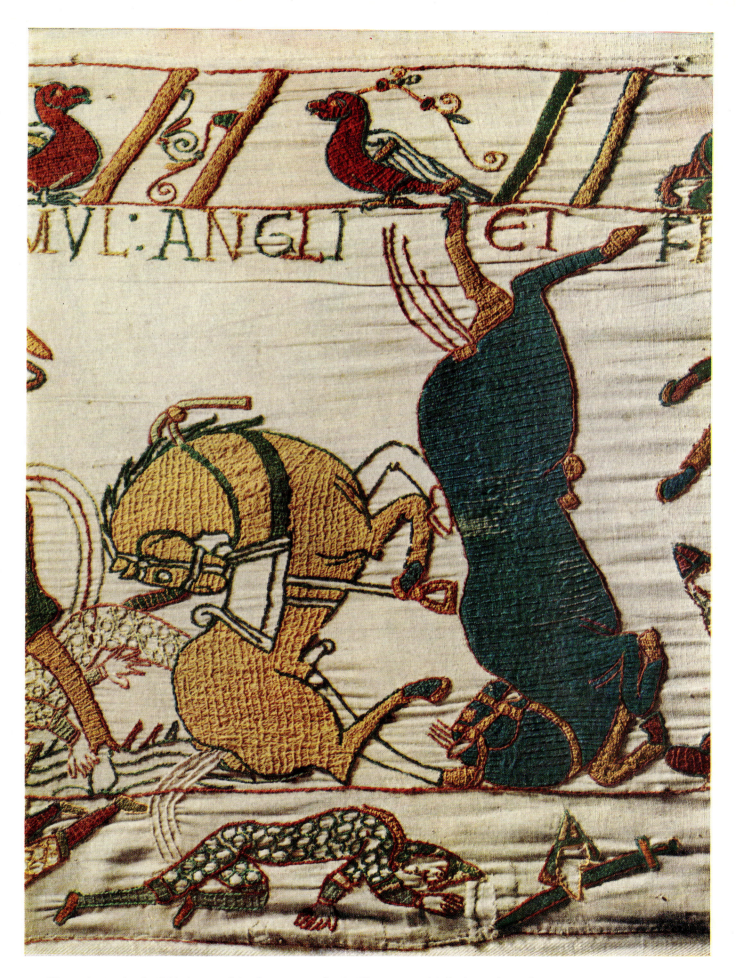

52 Horses in the battle. This is one of the finest scenes in the Tapestry, and it is almost incredible
that the art of embroidery can communicate such action and drama as we see here. The shapes of
the two fallen horses complement one another perfectly; the one falling over backwards with bent
legs; the other completely on end, rearing straight up from its twisted neck, with the rear legs waving
like semaphores. It is interesting to see that the designer has omitted the saddle, as it would have
ruined the flowing lines of the stricken animal.

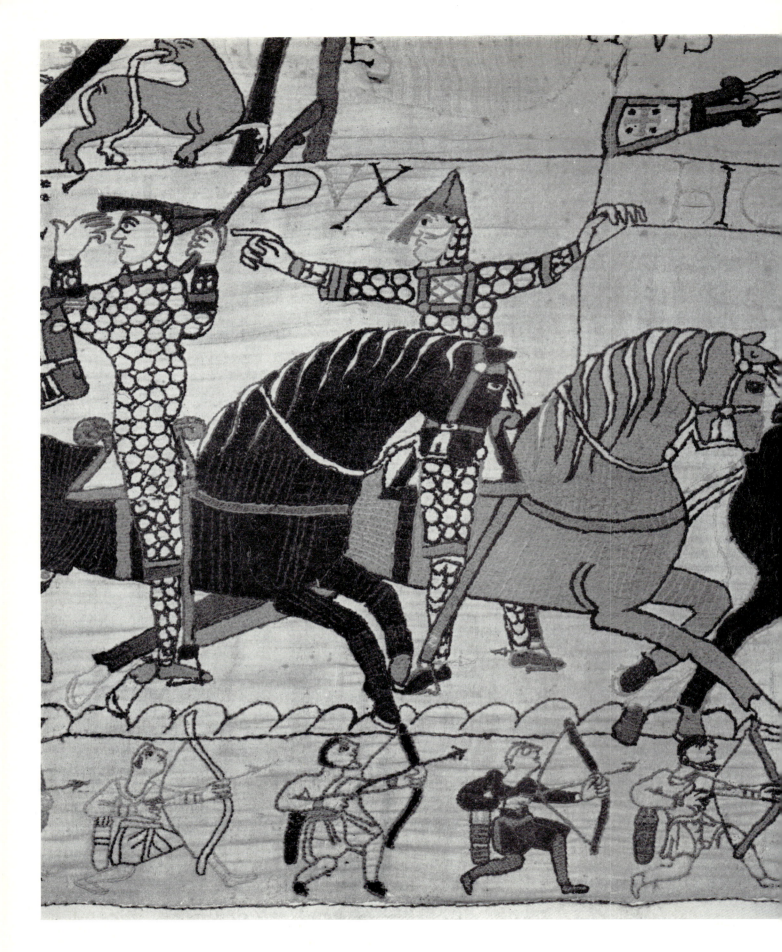

53 The incident shown here actually took place during the battle. After the English had routed the Bretons, a rumour spread that William had been killed. Whereupon the Duke turned in his saddle and pushed up his conical helmet to show his face and rally his troops. This gesture was no easy task, as the nasal was fixed to the rim, and if one did not hold fast to it, the helmet would slide backwards off the head. On the right is seen the Papal Banner, which – carried upright by a Norman knight – waves bravely in the upper border (see page 13). The knight has been suggested to be Turstin de Bec, but there is no evidence for this. Archers crowd the lower border.

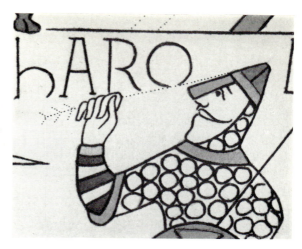

his enlargement shows the last figure of the preceding group in which we see a
er of the English headquarters staff grasping an arrow in his right hand: this figure
o be called Harold, and it used to be said that the arrow was piercing his eye; all of
is nonsense. It is not Harold, and anyway the arrow is going nowhere near his eye,
be seen in the small illustration above this scene, which is taken from Stothard's
ng of the Tapestry, in which he included the original positions of the stitch-holes –
ollen thread had been worn away when he saw it – which go right up to the helmet.
discussed in the section entitled 'The Death of Harold' on page 15. The main and
te scene is the death of Harold in battle, hacked down by a Norman knight. As he falls,
lets go the great Danish-type axe with which he has been fighting.

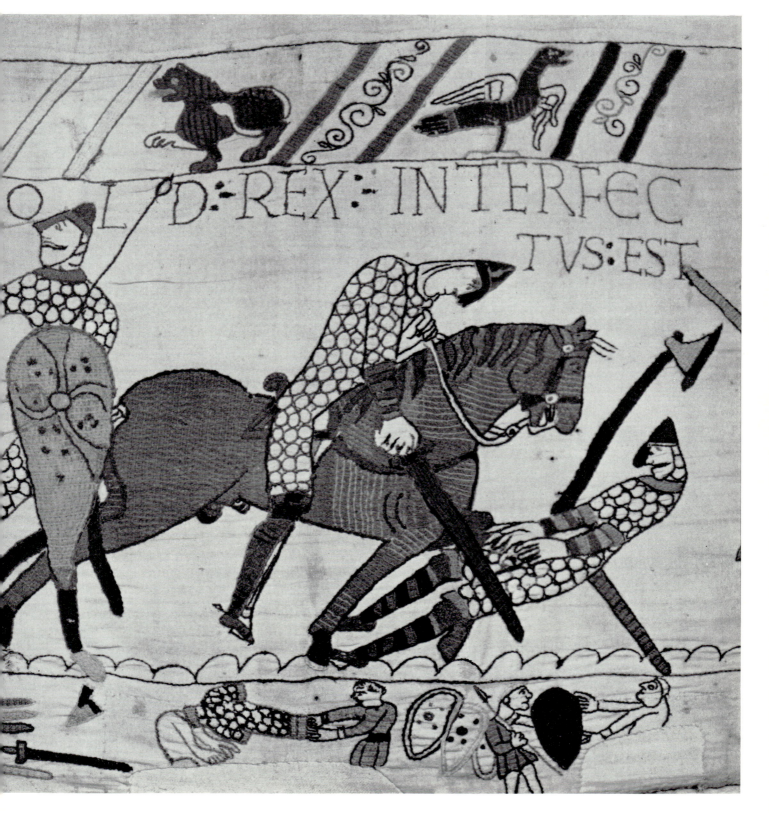

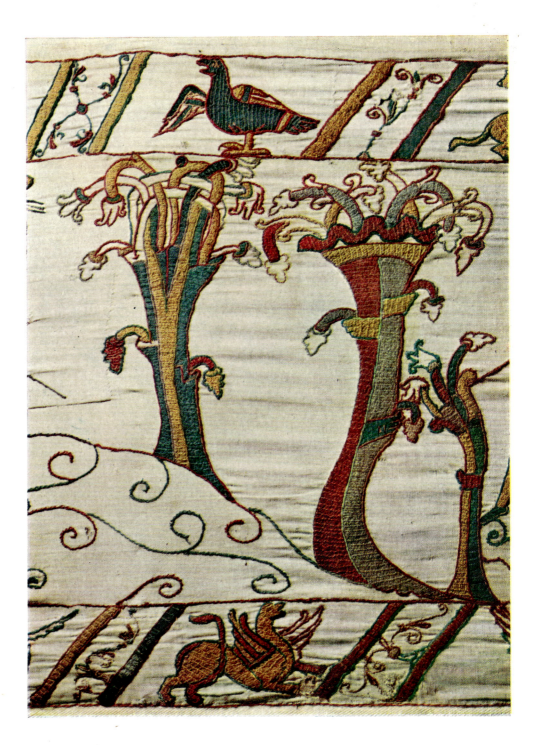

55 This plate of trees, and the rise of a hillock, gives a clear idea of the wonderful manner
in which the designer dealt with the problem of the flora as opposed to the fauna. He used
trees chiefly as dividing elements in his long narrative, which separate scene from scene.
In doing so the trees have become decorative motifs on their own, designed and executed
with a perfect eye for objects which must suggest their organic nature, and yet be decora-
tively monumental. The convention adopted for the hill is also highly effective, with its
curving outline and the space-filling 'tendrils' of different colours. The colour schemes are
also worthy of special note, and the harmony of form is matched by a fine sense of harmony
in colour.

Harold lay elsewhere

THE memorial stone marking the spot where King Harold was slain at the Battle of Hastings has been moved. It's part of a £1.8 million revamp of Battle Abbey by English Heritage ahead of the 950th anniversary of the battle that changed the face of medieval England. After William the Conqueror's victory on Senlac Hill in October 1066, he founded the abbey as atonement for the bloodletting. The high altar, of which nothing remains above ground, was situated where Harold fell. However, new research places the altar nearly 20ft to the east and the memorial has been moved accordingly. There is an exhibition about the battle and the public has access to two previously unseen areas of the abbey. They can climb 66 steps to the top of the remarkably preserved 14th-century Great Gatehouse for a sweeping view of the Wealden landscape and they may find it inconceivable that this tranquil view once saw such carnage that the hills were said to seep with blood after heavy rain. The abbey became one of the richest religious foundations of the time and visitors can pass through an immense doorway into the monks' huge dormitory (www.english-heritage.org.uk/ battleabbey). *Jack Watkins*